IMAGES
of America

EWALD BROS.
DAIRY

IMAGES
of America

EWALD BROS.
DAIRY

William D. Ewald

ARCADIA
PUBLISHING

Published by Arcadia Publishing
Charleston, South Carolina

Printed in the United States of America

Library of Congress Control Number: 2017933417

For all general information, please contact Arcadia Publishing:
Telephone 843-853-2070
Fax 843-853-0044
E-mail sales@arcadiapublishing.com
For customer service and orders:
Toll-Free 1-888-313-2665

Visit us on the Internet at www.arcadiapublishing.com

This book is dedicated to the staff of Behavior Therapy Solutions of Minnesota in recognition of the extraordinary mental health support they provide patients diagnosed with mental health issues and their treatment of children diagnosed with autism spectrum disorder. All of the author's royalties from the sale of this book will be donated to the facility in support of its continued care and resources for those in need.

CONTENTS

ACKNOWLEDGMENTS

Compiling this book was an enormous privilege entrusted unto me by my family members along with the encouragement of the great citizens of North Minneapolis. My mother and father provided steady help, love, and encouragement to bring this story to life. My father's daily support throughout this process will forever be appreciated. The steadfast patience of my wife, Roxanne, will never be forgotten. Our children and co-archivists, Christopher and Nicole, provided wonderful assistance and encouragement along the way. A special thank-you is owed to Steve Hamborg, son of longtime Ewald driver Einar Hamborg; Steve is perhaps the foremost authority on the Minneapolis dairy business and provided invaluable information and factual validation of images, dates, and supporting documentation.

Unless otherwise noted, the images contained within this book came from the Ewald family archives, with additional photographs and stories shared by past Ewald employees and their families.

I would also like to acknowledge Minneapolis photography studio Norton & Peel for preserving our family's images and gifting them exclusively to the family for our use. Thanks are given to Don Anderson of the Golden Valley Historical Society, the Minnesota Historical Society, and Diane Jacobson Mcgee of the Robbinsdale Historical Society. The images in this book span many decades, and several are over 100 years old, which required the technical scanning assistance of Paul Eide and Bryan McGovern. The Naegele family provided interesting photographs and supporting details. Thatcher Imboden, coauthor of *Uptown Minneapolis*, provided the initial introduction to Arcadia Publishing as well as encouragement in the early stages of the proposal. A very special thank-you is owed to Arcadia title manger Liz Gurley for her constant professional support and patience.

INTRODUCTION

I will prepare and someday my chance may come.

—Abraham Lincoln

The Ewald family first arrived in the United States in 1884 aboard the passenger-cargo steamship SS *Indiana*. The recently widowed Moa Ewald and her young Danish family of three boys and two girls, ranging in ages from four to fourteen, boarded the sturdy iron ship with no more than the clothes on their backs, limited savings, and a handful of blankets. During the three-week voyage to America, the blankets would prove necessary as the ship was filled over capacity and the family had to huddle in hallways for rest and to pass the time, as there were no rooms available.

After their arrival at Ellis Island, Moa and her children first set out for Wisconsin, which was well known for its great abundance of farmland and opportunity. After a brief stay, the family moved to Minnesota, where friends awaited them and provided shelter while the young family settled into their new country. The Ewalds eventually moved to a small farm at Forty-Fifth Street and Twenty-Eighth Avenue South in Minneapolis, an area near what is now the eastern boundary of Hiawatha Golf Course.

Moa's oldest son, Chris, who turned 14 that year, secured a job as a helper on a milk route in South Minneapolis. Undaunted by his inability to speak English, young Chris greeted his employer with a hearty "goodag," delivered with a strong Danish accent. Fired with zeal to support his mother and siblings, Chris studied the new language closely and became increasingly proficient. Two years later, at age 16, he used the family's meager savings to purchase his employer's milk wagon, horse, and route. With the help of his younger brother John, Chris started the Ewald Bros. Dairy. The milk they distributed was produced on the Ewald family farm by cattle that John herded when he was not helping his brother. John, who was nine years old at the time, soon left to begin his own business, Minneapolis Hide and Tallow.

Chris was determined to grow the family dairy as his sisters tended to the obligations of the farm. Soon after starting the business, Chris married Gertine Hanson, and together, they had four sons and three daughters, Bob, Dewey, Ray, Don, Vera, Florence, and Mae.

At that time, Golden Valley was primarily agricultural and undeveloped. William W. McNair, a prominent figure in public affairs, died in September 1885 and left the management of his estate to a son-in-law, who in turn negotiated an agreement to lease the sprawling hills and farmland to Chris. In 1911, Chris, with the assistance of his brother John, moved the family and their herd from their home in South Minneapolis across town to the new farm. It comprised 700 acres of hills and pastures and was located on what is now known as Theodore Wirth Park and Golf Course on the Minneapolis–Golden Valley border reaching across Olson Memorial Highway and stretching to the Robbinsdale border.

After completing the move to the farm, Chris and his oldest son, Robert, ran the farm, and Ray and Dewey, who had previously been pulled out of school in the eighth grade to assist the rapidly growing business, delivered the milk.

During this time, milk was still delivered to homes twice daily since iceboxes could not keep it from spoiling overnight. The milk was dipped out of a milk can that had been previously processed in the Ewald family kitchen with quart- and pint-sized dippers and poured into pitchers, which customers brought to the Ewald wagon. Ice-filled burlap bags kept the milk cool while in the wagon.

Chris's son Ray left for service with the 14th US Cavalry in 1917 but rejoined the firm after completing his two-year enlistment. Originally declined entry into the service for his limited education, Ray was eventually accepted for his strong knowledge and proven work ethic as a farmer. By the time Ray returned, the dairy had grown to include 36 horse-drawn wagons and three motorized milk trucks.

As the dairy business continued to grow, Chris purchased five acres of land on the Minneapolis side of Xerxes Avenue. The first Ewald milk plant, which was built on the northwest corner of Nineteenth and Xerxes Avenues, was directly across the street from the farmhouse and dairy barns of the McNair farm. The new state-of-the-art creamery was completed in 1920. The dairy included an automatic milk bottler and capper along with pasteurization and processing equipment.

The creamery could handle more milk than the Ewald farm produced, and soon, other farmers began delivering their milk to the dairy for processing and distribution. The Ewald family eventually moved off the family farm in 1923 to a house they had built at 2800 Nineteenth Avenue North. This transition meant they had to purchase all the milk they processed since they sold their cattle at the time of the move.

Prior to the Great Depression, the creamery was remodeled and expanded, and in 1927, a second story was added. During the 1920s and early 1930s, significant health safeguards were implemented at the creamery. Dairy herds were inspected and registered, and milking was conducted under sanitary, supervised automatic milking machines. Ladling milk out of cans had long since been replaced by bottling. Bottles were washed, sterilized, and capped by contamination-proof lids that had seals to protect the rims of the bottles. Every spring, the interior of the dairy was painted with a high-gloss white enamel paint to maintain the cleanliness for which the dairy was known.

A large portion of the dairy's business was door-to-door deliveries. The dairy continued to use horses and wagons until the 1930s, when they were replaced by a fleet of trucks that would reach 130 vehicles at its peak. Horses were preferred during the early part of the century because they would learn the routes, stopping in front of each customer's homes without being directed. Furthermore, the horses, all purchased from the Minnesota State Fair, could be bought for less than the price of a truck (approximately $100) and provided about 12 years of service.

During the 1930s, the Ewald Bros. Dairy became the exclusive distributor of Golden Guernsey milk in the Twin Cities area. Golden Guernsey was nationally recognized as a brand name for milk produced by purebred, registered Guernsey dairy herds. Guernsey milk was richer in butterfat and other important nutrients and vitamins and was distinctive in that it had a golden-yellow color and unique, rich flavor. The Guernsey herds were strictly supervised by the American Guernsey Cattle Club and Golden Guernsey Inc. The herds were inspected regularly by Golden Guernsey along with Ray Ewald.

By 1965, the Ewalds were supplied by a record 60 Golden Guernsey herds. Most of them were located within a 50-mile radius of the creamery so that it could receive fresh, raw milk daily.

After Chris's death in 1938, the four sons took over the dairy, which had become very successful and popular. By the 1960s, Ewald Bros. Dairy's milk routes spread across Minneapolis and surrounding communities. Deliverymen went as far north as Anoka, as far south as the Minnesota River, and as far west as Minnetonka. During its peak, Ewald Bros. Dairy competed with over 80 home-delivery operations and delivered milk to one out of every three customers taking home milk delivery.

The Ewald brothers attributed their success to the values instilled in them by their father, Chris; the devotion of the employees, who never staged a labor dispute; and the quality of their milk.

The dairy celebrated its 75th anniversary in March 1961 with a parade that reenacted the 1911 cattle drive across town. It started at the original homestead in South Minneapolis and ended at the dairy. This time, 50 of the Ewalds' 130 milk trucks were used to represent the number of their original herd.

After World War II, it became less economical to deliver milk house-to-house because the costs of sending a milkman and a truck to homes, while trying to provide low-cost, high-quality products, were too great. As a result, supermarkets began selling milk. The major transition began in 1966 when Ewald Bros. Dairy's customers began buying more of their milk from supermarkets. During 1976, Ewald Bros. Dairy maintained 25 wholesale milk routes, which delivered to supermarkets, schools, and restaurants in Minneapolis, Duluth, and some parts of Iowa, as well as approximately 30 home routes, which accounted for roughly half of all home-delivery routes in the cities.

Contributing significantly to the decrease in sales was the decision previously made by the only surviving brother, Dewey Ewald, to discontinue the family's relationship with the premier brand Golden Guernsey. The dairy also dropped its widely successful outdoor advertising program with Naegele Outdoor Advertising and discontinued all radio advertising with WCCO radio.

Dewey sold the business in the early 1970s to a private party that immediately dropped most of the home-delivery routes to focus on the retail trade. The amount of milk sold began to flourish, and the refrigeration was expanded. In 1979, the company reported annual revenue in its last year of operation to be $13 million. By this time, the number of employees had dropped to 150, which was well below the 300 workers the Ewalds once employed.

The company filed for reorganization under federal bankruptcy laws in October 1980, and the following January, the former headquarters and dairy buildings, which at one time bottled 250,000 quarts of milk per day, were vacated and placed for sale. Milk processing at the dairy had ceased the previous August. The building sat vacant until it was demolished at the end of February 1982.

Even after the building was demolished, Ewald Bros. Dairy remained in business, and Marigold Foods produced milk using the Ewald name and delivered in Ewald trucks. The dairy still existed, but in name only. Many companies have shared the fate of Ewald Bros. Dairy, but it nonetheless was unique. When the dairy was sold by the family in the early 1970s, it was the only independent, family-owned, home-delivery operation left in Minnesota. The milk route that Chris Ewald purchased in 1886 was the only route the Ewalds ever purchased. Their competitors had grown by merging or buying out smaller operations. But the Ewald Bros. Dairy had kept pace by simply widening its distribution area, focusing on quality and delivery.

In 1986, the last of the former Ewald trucks was repainted to reflect new ownership, and the once famous Ewald Bros. Dairy brand existed no longer.

One

THE DREAM OF
CHRIS EWALD

Any American dream should start with someone wanting something, and suddenly finding at hand the opportunity and means of making their dream come true.

A worthy idea and stout heart joined together over 130 years ago when Chris Ewald started his milk route. The concept was new in an era of "let the buyer beware." Chris intended to sell only the best possible milk and to build a business on quality and service. The start of the milk route in 1886 meant much to the 16-year-old Danish lad who had first set foot in America two short years before. Chris knew that with quality, friendliness, and service, his route would be successful.

His dream would take a lot of work in producing and caring for the milk, delivering it to his customers, and looking after his farm and cattle. Chris knew he wanted to sell the world's finest milk, and his hard work brought the rewards and results he wanted.

Times changed, and Chris witnessed milk being delivered in bottles instead of being ladled out of cans and into the pitchers of his waiting customers. He saw horse-drawn milk wagons change to refrigerated trucks and raw milk from untested herds change to inspected registered herds of purebred Guernsey cows. He saw sanitation become a watchword in his dairy, with automatic bottle washers, sterilizers, and fillers with sterilized equipment for caps and seals.

Early on, Chris added the fourth cornerstone to his business model: in addition to friendliness, quality, and service, Chris included loyalty to himself, family, and fellow coworkers, and to the public. Supremely loyal himself, he asked that every individual connected with the dairy have the same standards. The years have proved Chris Ewald's wisdom as his dream prospered for nearly 100 years.

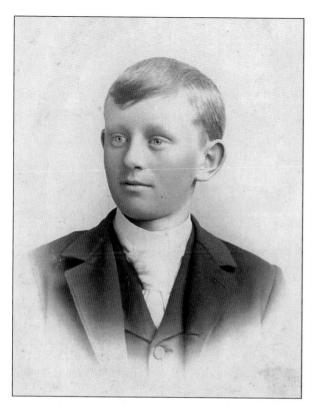

This 1877 photograph, taken in Denmark, shows a seven-year-old Chris Ewald. In just seven years, Chris, at age 14; his widowed mother, Moa; and four siblings would depart their native land in 1884 in hopes that America would provide an opportunity for the family. Arriving in the United States, the Ewald family traveled to Minneapolis, where relatives awaited. Unable to speak English, Chris secured a position as a helper on a milk route to help support his family. He quickly became fluent in English, and eventually purchased the milk wagon, horse, and route from his employer, marking the beginning of the Ewald Bros. Dairy in 1886.

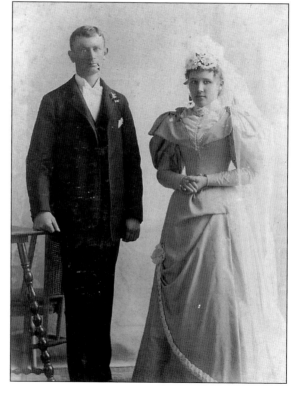

Chris married Gertine Hansen in 1892, and soon after raised a family of four boys and three girls. After they completed the first through eighth grades, all four boys entered the family dairy business. The girls would complete high school and help on the growing family farm and share in the responsibilities of processing the milk. This was done in the family's kitchen prior to the development of the dairy.

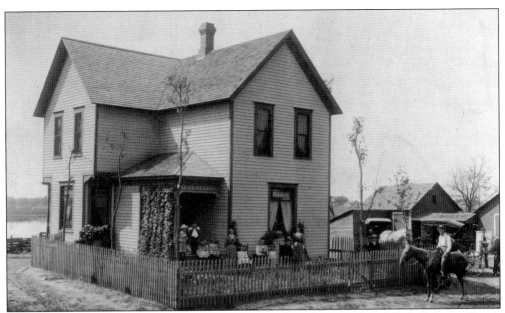

The original farmstead is shown here in 1904 at Forty-Fifth Street and Twenty-Eighth Avenue South overlooking Mud Lake (now Lake Hiawatha) on the east edge of what is now Hiawatha Golf Course. Pictured at right are Ray (in yard), Chris (behind Ray), and Dewey (on horse). The farm would soon be outgrown by the growing family and farmhands. Chris and brother John herded the cattle from South Minneapolis to the McNair farm in Golden Valley. Their new home sat on 700 acres of sprawling hills on the western edge of Golden Valley, an area that later became Theodore Wirth Park.

The McNair homestead became the Ewald home for the next nine years. The large home near Xerxes Avenue and Nineteenth Avenue North housed not only the Ewald family but the farmhands as well. Chris leased this land for $1 per acre to house his several hundred head of dairy cattle and 54 horses for the milk wagons. This home was the first processing facility for the Ewalds, as the milk was processed in the family's kitchen. Later, the decision was made to build a creamery in response to 1916 legislation introduced by the Twin Cities Milk Producers Association governing the distribution of milk.

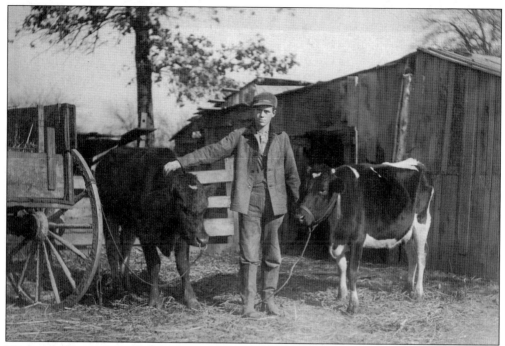

Upon completing the eighth grade, young Dewey Ewald tended to the family farm prior to his primary responsibility of delivering milk. Both Dewey and Ray left school to assist their father, Chris, with the growing needs of the family farm and milk delivery. Ray and Dewey would grow with the dairy and eventually became co-presidents of the business.

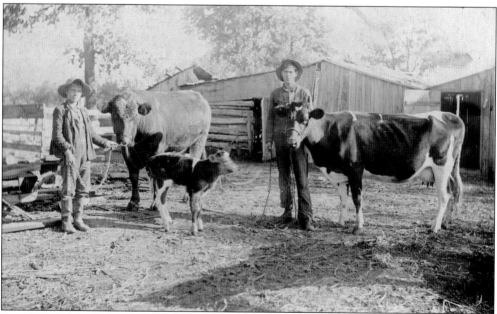

Ray (left) and Dewey Ewald tend to the family herd of cows. Ray would complete his chores before going to school and join brother Dewey afterwards for the remainder of the day's work. After graduating from the eighth grade, Ray joined his family full time in supporting the family dairy.

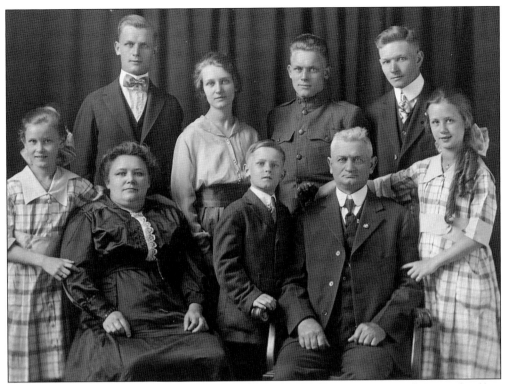

The Chris Ewald family is pictured in August 1917. Family members are, from left to right, (first row) Florence, Gertine, Don, Chris, and Vera; (second row) Dewey, Mae, Ray, and Robert. This photograph was taken shortly before Ray left for the war. He served two years in the cavalry before returning to the family business to assist Chris and Dewey.

Here is a 1936 advertisement for the Ewald Bros. Dairy. The ad shows a proud Chris Ewald, shortly before his death, and his four sons. Dewey, Ray, Don, and Robert would carry on the family business for decades to come. The Ewalds capitalized on cleanliness watchwords, such as "purity," in their advertising to help promote the creamery's commitment to food safety and sanitation.

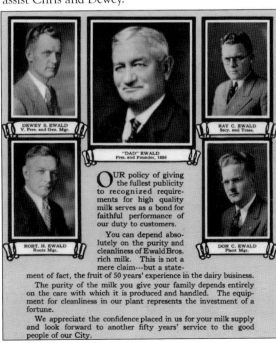

DEWEY S. EWALD
V. Pres. and Gen. Mgr.

"DAD" EWALD
Pres. and Founder, 1886

RAY C. EWALD
Secy. and Treas.

ROBT. H. EWALD
Route Mgr.

DON C. EWALD
Plant Mgr.

OUR policy of giving the fullest publicity to recognized requirements for high quality milk serves as a bond for faithful performance of our duty to customers.

You can depend absolutely on the purity and cleanliness of Ewald Bros. rich milk. This is not a mere claim---but a statement of fact, the fruit of 50 years' experience in the dairy business.

The purity of the milk you give your family depends entirely on the care with which it is produced and handled. The equipment for cleanliness in our plant represents the investment of a fortune.

We appreciate the confidence placed in us for your milk supply and look forward to another fifty years' service to the good people of our City.

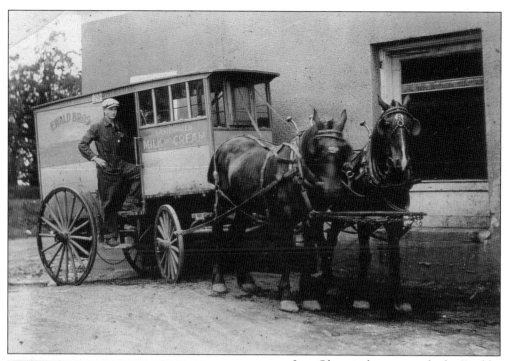

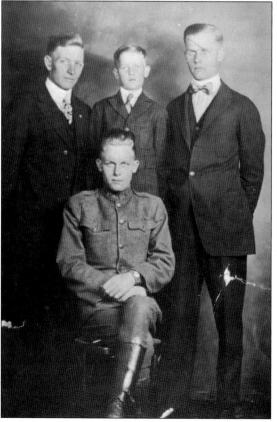

Jens Olsen is shown outside the Ewald stables located across the street from the dairy on Washburn Avenue. Jens was a family member and a very dedicated long-term employee. Once the Ewald milkmen picked up their wagons and hitched their horses, they would first be loaded with straw and ice, which would protect the items being delivered, and then proceed one block down the street to the dairy to be loaded with milk at the creamery. (Courtesy Dawn Simpson.)

Ray Ewald, sitting, is pictured with his brothers shortly before leaving his family farm on March 2, 1918, to join Troop L of the 14th US Cavalry. Ray had enlisted with the approval of his father, Chris, and was originally stationed in Texas. He was deemed qualified to enter the Army as his prior experience as a farmer was listed as "desirable." Ray is surrounded, from left to right, by Robert, Don, and Dewey.

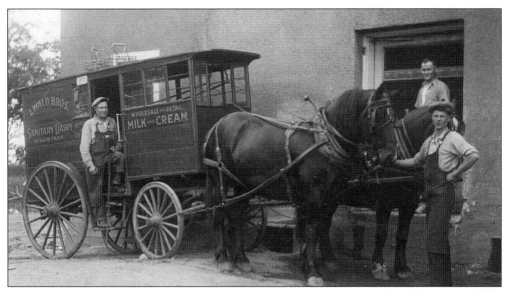

Through the years, the Ewalds used various styles of horse-drawn wagons to deliver their milk. This image features milkmen and stable men prepping the wagon and team for delivery. The wagons were originally stored alongside the dairy before the stable was built and expanded to house them. While out on deliveries, horses and milkmen faced some daily challenges, like inclement weather. The men used ice in burlap to keep the milk cold in the warmer months and utilized kerosene heating in the winter to keep the milk from freezing. In 1922, these wagons covered the entire Northside of Minneapolis, Lowry Hill, Bryn Mawr, and Robbinsdale.

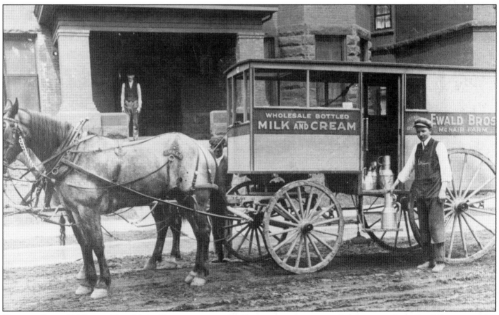

Pictured in 1918 is a Ewald milkman at one of his many stops in Minneapolis, the Minneapolis Courthouse. Many businesses and government organizations in Minneapolis relied exclusively on Ewald Bros. Dairy for their dairy products. The Ewalds at the time had approximately 40 horse-drawn wagons that would cover the routes. Later, motorized vehicles were added to help with the larger routes. Eventually, the fleet grew to 130 vehicles.

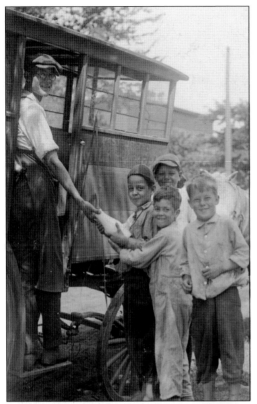

The Ewald family had numerous milk routes throughout Minneapolis and its suburbs. It is believed that there was an informal gentlemen's agreement with the St. Paul dairies that neither Minneapolis nor St. Paul dairies would cross the river into the other company's territory, and this agreement most certainly caused an early closure to some dairies on each side. Pictured in 1925, Ray Ewald, age 25, is making a commercial stop at the Unity House in Minneapolis and dropping off some ice-cold milk to waiting young boys. Two of these young boys would eventually join the dairy and become lifelong employees of the Ewalds. The Unity House was one of many "settlement homes" for families that needed assistance and work.

Once Chris Ewald moved off the McNair farm, he built this home directly across from the dairy in the early 1920s. Located at 2800 Golden Valley Road, the Ewalds resided at this home for decades, and it still stands today after undergoing a thorough restoration by the current occupants. The majority of the Ewald family resided in North Minneapolis within walking distance of the dairy. (Courtesy Craig Rognholt.)

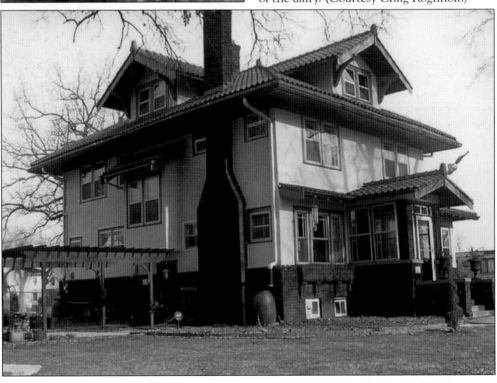

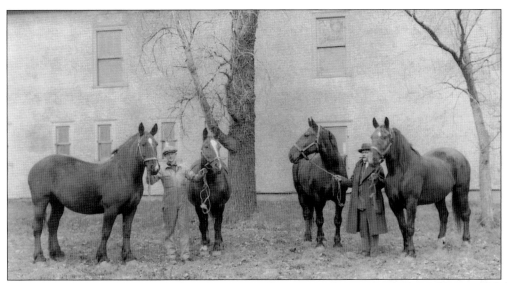

Ralph (left) and Chris Ewald, each with two prized horses, are shown outside the stables in 1928. Due to the large amounts of hay and feed stored within and the period's heating techniques, the stables burned several times. The stables and icehouse were also a popular place for children to congregate each afternoon on hot summer days to receive chunks of ice from the milkmen after their routes. The ice was put in burlap bags and placed atop the milk in the wagons and would drip cool water onto the bottles to cool them.

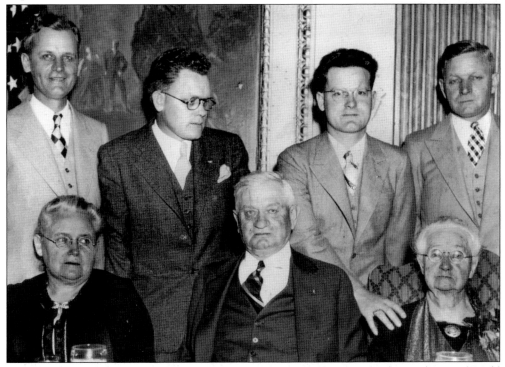

On April 3, 1936, the Ewald family gathers prior to the annual banquet for the employees of Ewald Bros. Pictured are, from left to right, (first row) Gertine, Chris, and Moa; (second row) Dewey, Ray, Don, and Robert Ewald.

No. 4229 **State Milk and Cream License** 1922-1923

FEE
$1

STATE OF MINNESOTA
DAIRY AND FOOD DEPARTMENT

This License Expires May 1, 1923

FEE
$1

Not Transferable

𝕿𝖍𝖎𝖘 𝕮𝖊𝖗𝖙𝖎𝖋𝖎𝖊𝖘 That _Ewald Bros_

whose business is _W_

at _2919 - 19 avno_ Street _Mpls_ City or Village

using _W_ vehicle whose driver is _____

_____ is hereby licensed

to sell Milk and Cream in the _City_ of _Mpls_

in said State from May 1, 1922, to May 1, 1923.

Issued _5/1/22_

By _H.D. Meyer_
Secretary.

Chris. Heen
Dairy and Food Commissioner

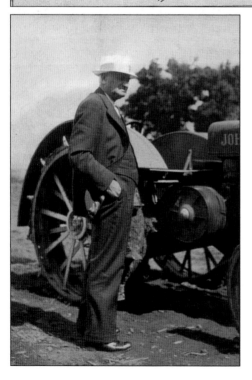

State licensing for dairy products was originally introduced in the late 1800s. The legislation was intended to regulate the dairy industry, particularly milk and cream. Ewald Bros. Dairy's very first milk and cream license was issued in 1922 shortly after family members built their first creamery and became producers and distributors of milk. Another primary purpose of the legislation and the licensing of dairy producers was to help stabilize markets and monitor production and quality of dairy products.

The Ewald family has the following saying: "You can take the farmer off the farm but can never take the farm from the farmer." Holding true to the saying, Chris Ewald is pictured in 1934 inspecting one of the many registered farms that supplied Ewald Bros. Dairy. Note the John Deer tractor.

As early as the 1900s, the City of Minneapolis established the Department of Public Welfare. One role of this department was to ensure food safety. Child care, schools, restaurants, and other organizations that could have a major impact on the health of the citizens adhered to a strict inspection and licensing program. Employees of this department would unexpectedly arrive at facilities, spend the day carefully combing through the required records, and conduct a thorough inspection of equipment. In Ewald Bros. Dairy's case, inspectors would go through the barns and stables as well. Once certified, the inspector would issue a document that would be posted publicly demonstrating the facility's compliance. Failure to comply would most certainly result in a shutdown that would be disastrous for a dairy.

A 1920 photograph of the original Ewald creamery accompanies an advertisement promoting "safe milk." At the time, Ewald Bros. Dairy was the only dairy in Minneapolis receiving and producing half of its own milk and purchasing the balance from dairymen, not farmers. The Ewalds often spoke of the close vicinity of the creamery to the dairy farms and used this form of advertising to convey the message.

EWALD BROS. SANITARY DAIRY PLANT

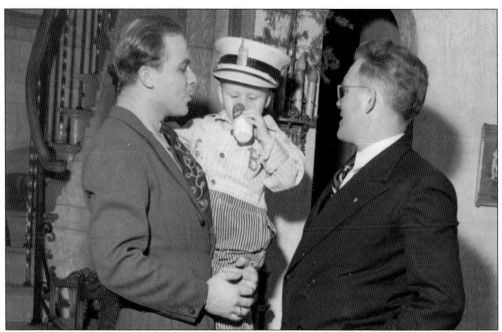

Seen in his childhood home, seven-year-old Douglas Ewald, son of Ray Ewald, proudly provides his family's Golden Guernsey milk to the local Golden Guernsey representative and his father, Ray Ewald. Douglas was used as a model for the creamery beginning at age two, and eventually became secretary and treasurer of the creamery. (Courtesy Schoen-Klammer studio.)

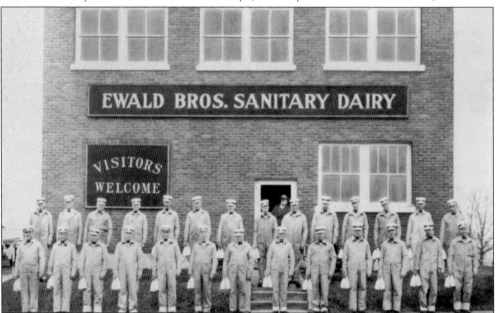

Taken after a second story was added to the Ewald creamery in 1920, this photograph shows Chris Ewald looking out from the doorway behind his milkmen. At the time, the Ewalds grew their business by focusing on larger portions of Minneapolis, eventually reaching as far west as Minnetonka. They never purchased a single route from a competitor, focusing instead on growing the business by name recognition and a strong reputation for quality and service.

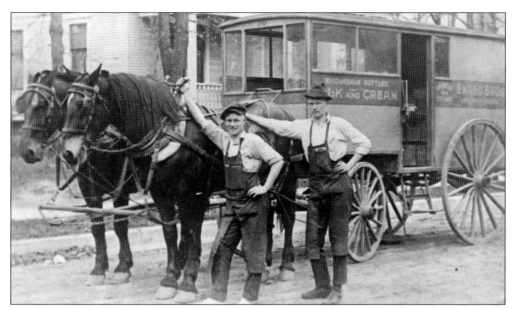

Ray (left) and Dewey Ewald are on the milk route in 1921. Ray had just recently returned from his enlistment and rejoined his brother helping their father, Chris, on the route. The teams of horses the Ewalds used were so proficient that they knew where to stop, recognizing their customers' homes. At the end of the day, the teams would walk the wagons back to the stables unaccompanied, with the milkmen returning directly to the creamery across the street.

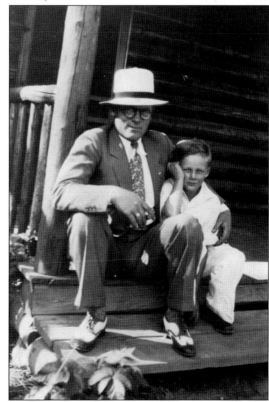

Contemplating the future in 1933 is Ray Ewald and son Graydon, age seven, at the Ewald family's cabin on Lake Waverly. In 11 years, Graydon would join the family business, initially as a milkman. The Ewalds owned the lakeshore property for nearly 30 years, eventually selling six of the parcels of land to vice presidential candidate Hubert Humphrey, a close friend of Ray's.

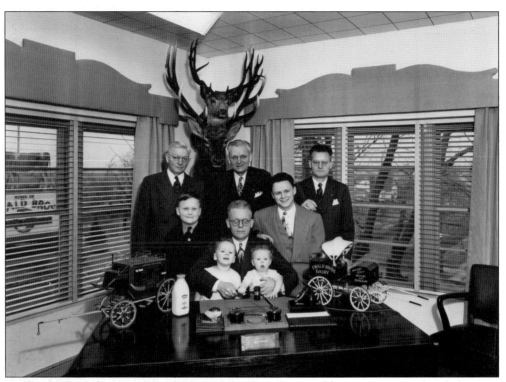

Ray Ewald is seen sitting at his desk at the Ewald creamery, located at 2919 Golden Valley Road, on March 10, 1947. He is shown with his three brothers, from left to right, Bob, Dewey, and Don. His two sons, from left to right, Doug and Graydon, are standing behind Ray, and his two grandsons are sitting in his lap. Ray's office overlooked much of Golden Valley, the former site of the McNair farm and what is now Theodore Wirth Park. (Courtesy Norton & Peel.)

Ray Ewald is shown on December 9, 1961, in a publicity photograph for the Salvation Army of Minneapolis. Ray and his wife, Ethel, served on the Salvation Army board for over 25 years. Among the many organizations the Ewalds supported, the Salvation Army remained near the top in terms of time and financial resources contributed. This was because, in Ray's words, "it was miraculous how fast the Salvation Army is able to work to invest their resources in human dignity and children's happiness." (Courtesy Zinmaster Studio.)

Ewald Bros. Dairy produced its own Danish Pride butter using a recipe that Chris became familiar with when he was a young boy in Denmark. The freshest of cream and other ingredients were used to make this creamy butter that Ewald Bros. Dairy became known for. These royal-blue stoneware crocks, made by Redwing in either one- or five-pound sizes, were filled with butter, covered with a soft cheesecloth, and delivered. The customers eventually returned the containers to be sanitized and reused. Eventually, the cost of sanitation and the added weight of the crocks, not to mention their fragility, led to their replacement with cardboard cartons.

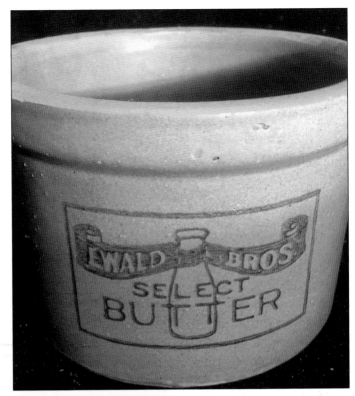

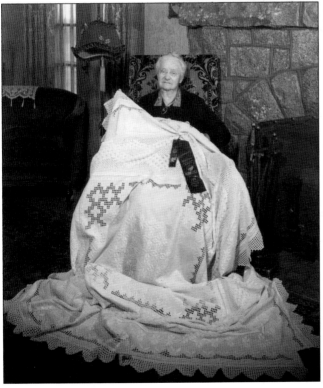

Mina "Ma" Ewald (1845–1936) is shown here in 1932 with a blue ribbon–winning quilt from the Minnesota State Fair. Mina lived a long life and enjoyed the fruits of the labor from the family business. At the start of the company, she helped with the production of milk in her family's kitchen, hosted the company Christmas parties in her home, and prepped meals for the family as well as the numerous farmhands the Ewalds boarded. (Courtesy Norton & Peel.)

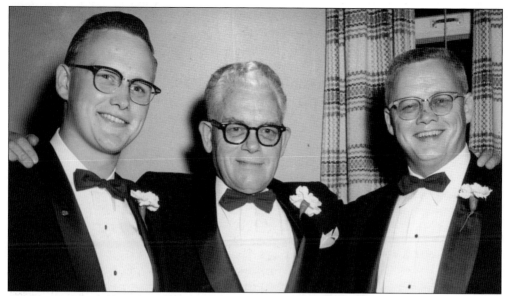

Celebrating his wedding day at Trinity Lutheran Church in South Minneapolis in 1958, Douglas Ewald (left) is joined by father, Ray, and brother Graydon. Douglas and Virginia "Ginny" Eide eventually raised six children. The Eide family of 10 were previous customers of Northland Milk prior to Doug and Ginny dating. Once the relationship became more established, the Eides cut ties with Northland Creamery and became Ewald customers. The Northland driver who lost the Eide account commented to Doug Ewald: "That's a heckuva way to earn an account."

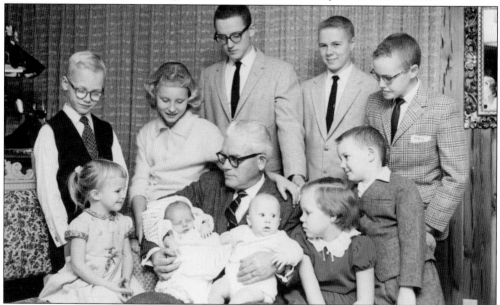

Relaxing at home, Ray Ewald is seen with his grandchildren in Minnetonka on December 27, 1959. The four children on the left are Daniel Jacobsen, age 9; Christine Jacobsen, age 11; Cathleen, age 3; and sleeping Elizabeth, 1 month; they are Douglas and Patricia Jacobsen's children. The five children on the right are those of Graydon Ray and Diane Ewald; from left to right are Clinton, age 15; Timothy, age 13; Steven, age 11; Carolynn, age 7; and Randall. The baby on the right is three-month-old David Clyde Ewald, son of Douglas and Virginia Ewald. (Courtesy Doug Jacobsen.)

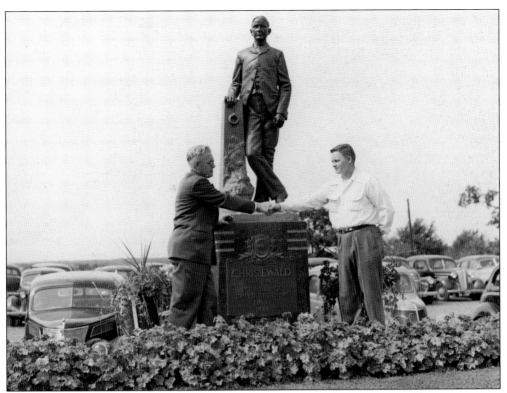

A watchful statue of Chris Ewald looks on as Ray Ewald (left) shakes the hand of his son Graydon as he returns from the Marines and joins Ewald Bros. Dairy. Graydon served as a corporal in World War II. He would dedicate 30 years to the family-owned and -operated Ewald Bros. Dairy before moving to Arizona. Graydon, like his father, was instrumental in community service, providing his assistance to the Masons, Scottish Rite, Lions Club, auxiliary police, Golden Valley Health Center, Red Cross, and Boy Scouts of America. (Courtesy Norton & Peel.)

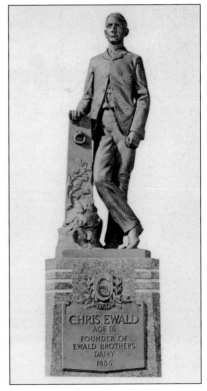

The statue of Chris Ewald was located directly across from the Ewald creamery. It was given to the state and the Minnesota Historical Society in a 1947 dedication led by Gov. Luther Youngdahl, Ray Ewald's childhood friend.

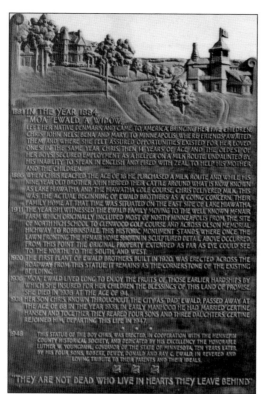

The large plaque on the base of the statue was salvaged by a family member and preserved in 1983. Chronicling the history of the dairy from the beginning, this plaque was part of the dedication ceremony when the statue of Chris Ewald was put in place in 1947.

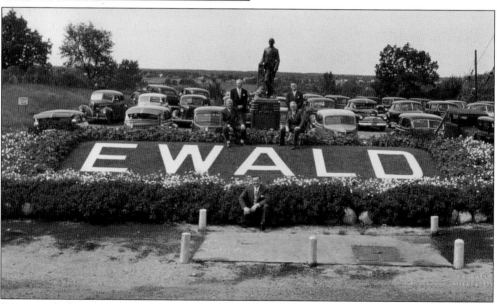

Posing with the statue of their father, Chris, the four Ewald brothers are, from left to right, (first row) Dewey and Ray; (second row) Bob and Don. The statue was in the parking lot across the street from the dairy on the Golden Valley side of the Ewald property. This portion of the land was given to Hennepin County by Ewald Bros. on the day of the statue's dedication. Immediately behind the statue was the employee parking, which overlooked the original 700-acre McNair farm. (Courtesy Norton & Peel.)

Two

From Horse-Drawn Wagons to Trucks

Originally running a true one-horse operation in 1886, Chris Ewald soon acquired additional wagons and teams of horses. As his milk routes expanded, so did the number of horses, wagons, milkmen, and farmhands. Chris had a steady source of high-quality purebred horses that he purchased every year from the Minnesota State Fair. The horses, now paired in teams due to the increasingly heavy weight of the wagons and product, became so proficient that not only did they learn their drivers' routes, they also would walk themselves through North Minneapolis to the blacksmith on Broadway Avenue for shooing, returning once the job was completed. The Ewalds eventually saw their horse-drawn fleet grow to 40 wagons and over 100 horses.

The first mechanical truck was purchased by the Ewalds in the late 1920s, with a second and third added shortly after. These early trucks lacked the modern conveniences of refrigeration and heat and required an enormous amount of ice surrounding the milk bottles to ensure they were kept cool. Straw also encased the bottles to prevent breakage.

The three mechanical trucks were primarily used to reach larger institutions at the time and provided the growing dairy the expansion capacity needed to develop its routes.

Horse-drawn wagons were phased out in the early 1930s, which gave way to an incoming fleet of International brand delivery trucks produced in St. Paul, Minnesota. Eventually, the fleet was fully modernized, with Divco brand trucks the preferred delivery vehicles of multi-stop establishments. The Ewalds' Divcos also came from St. Paul, and would eventually make up a fleet of 130, all of which could be stored inside the dairy.

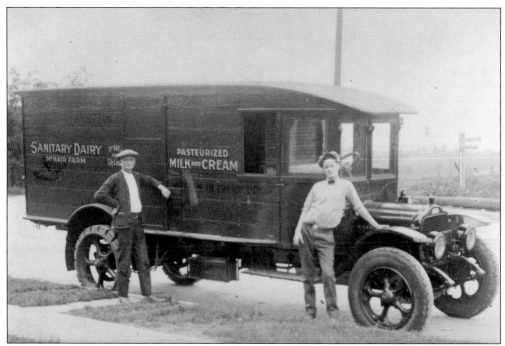

Chris and Dewey Ewald are shown shortly after the second-story addition to the rapidly expanding Ewald dairy. A new motorized fleet of three trucks was added in the 1920s. This new fleet greatly expanded the Ewalds' potential territory. These trucks had solid rear tires, providing for a rough ride, but were eventually upgraded to traditional tires. During the 1920s, these three trucks provided commercial support to the nearly 40 horse-drawn wagon routes.

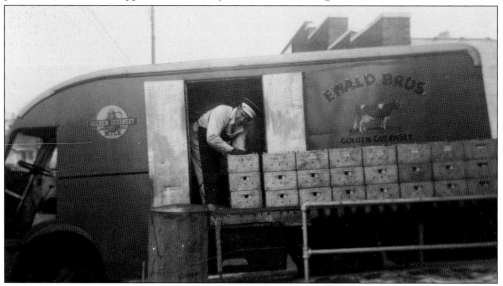

In 1938, to promote the exclusive distributorship the Ewalds had secured with the nationally recognized brand, the Golden Guernsey name was added to the sides of their milk trucks. Often beginning at 3:00 a.m., the loading of the Guernsey milk took place on outside conveyors. The milkmen carefully loaded the 45-pound crates onto the trucks and shuffled the empties forward as the routes progressed.

Once the trucks were fully loaded, the milkmen began their routes in the dark. Often, customers left their front doors unlocked for the milkmen to enter and fill the refrigerators. Other times, the fresh milk was left on the porch or in the insulated porch boxes that the Ewalds provided their customers. Milk left outside in the winter would often produce frozen cream at the top of the bottle, providing a nice treat for the consumer.

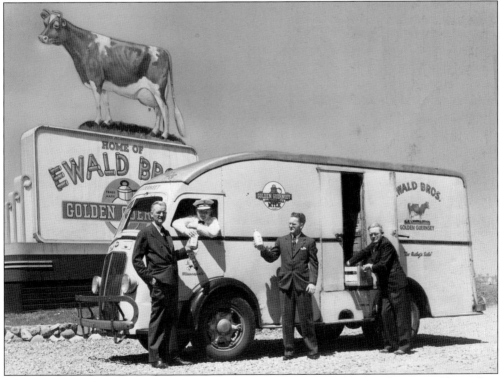

This promotional photograph shows, from left to right, Dewey, Don, and Ray Ewald standing outside a new truck in 1938. The billboard promoting Ewald Bros. Dairy was located directly across from the creamery. Ralph Ewald, cousin of the brothers, is in the driver's seat. (Courtesy Norton & Peel.)

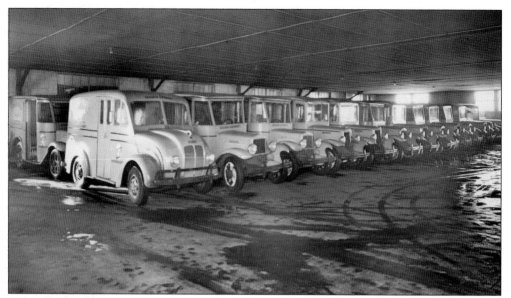

Inside the Ewald two-story garage sits a brand new Divco truck on the left. Parked next to the older, less-efficient International trucks, this vehicle was the first of 130 to be delivered to Ewald Bros. Dairy. Once Ewald Bros. took delivery of a vehicle, the trucks were moved to an internal paint booth where they received a coat of high-gloss paint and had their decals applied and were readied for delivery. The entire Ewald fleet was stored inside the creamery and utilized both floors of the garage, accessing the upper level by a long ramp. The trucks were washed daily and reloaded upon the milkmen's return. (Courtesy Norton & Peel.)

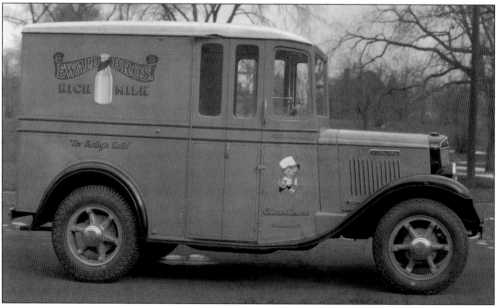

This International truck had a significantly smoother ride, which helped prevent breakage of glass bottles. Approximately 60 of these trucks were added in the early 1930s to accommodate the growing routes and alleviate the demands on the horses. Although more expensive than teams of horses, the added reach of the motorized delivery vehicles resulted in a growing customer base and increased sales. (Courtesy Norton & Peel.)

A one-year-old Douglas Ewald is shown in this 1938 advertisement introducing the well-known producer Golden Guernsey to the Ewald brand of milk. Golden Guernsey replaced Quality Park Farms as the original Ewald label and was the premier label for the company for decades. The Ewalds were known for always using family members or employees in their advertising, particularly the babies or young children, to reiterate their commitment to quality, sanitation, and food safety for young children.

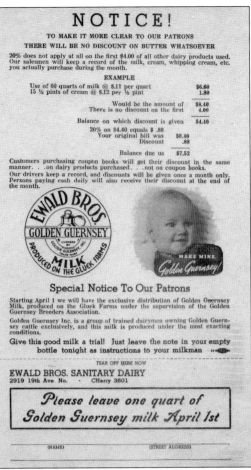

NOTICE!

TO MAKE IT MORE CLEAR TO OUR PATRONS
THERE WILL BE NO DISCOUNT ON BUTTER WHATSOEVER

20% does not apply at all on the first $4.00 of all other dairy products used. Our salesmen will keep a record of the milk, cream, whipping cream, etc. you actually purchase during the month.

EXAMPLE

Use of 60 quarts of milk @ $.11 per quart	$6.60
15 ½ pints of cream @ $.12 per ½ pint	1.80
Would be the amount of	$8.40
There is no discount on the first	4.00
Balance on which discount is given	$4.40

20% on $4.40 equals $.88
Your original bill was $8.40
Discount .88

Balance due us $7.52

Customers purchasing coupon books will get their discount in the same manner. . .on dairy products purchased. . .not on coupon books. Our drivers keep a record, and discounts will be given once a month only. Persons paying cash daily will also receive their discount at the end of the month.

Special Notice To Our Patrons

Starting April 1 we will have the exclusive distribution of Golden Guernsey Milk, produced on the Gluek Farms under the supervision of the Golden Guernsey Breeders Association.

Golden Guernsey Inc. is a group of trained dairymen owning Golden Guernsey cattle exclusively, and this milk is produced under the most exacting conditions.

Give this good milk a trial! Just leave the note in your empty bottle tonight as instructions to your milkman

TEAR OFF HERE NOW

EWALD BROS. SANITARY DAIRY
2919 19th Ave. No. - CHerry 3601

Please leave one quart of Golden Guernsey milk April 1st

(NAME) (STREET ADDRESS)

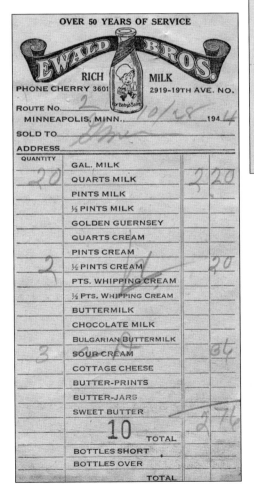

Order slips like this were left with the customers and filled out prior to the next scheduled delivery. At this time, butter was being produced and packaged in cartons as well as still being offered in jars. Note the use of "rich milk" on the order form; this reiterated that the company offered nutrient-rich products.

Notice to our Patrons

Beginning Sept. 16, we will discontinue all discount on coupon books.

This action is necessary in order to give our employees a six day week (now required by law) rather than a seven day week as has been our practice prior to Sept. 1, 1923.

Knowing our patrons would prefer this to a raise in milk prices, we have decided upon this action.

Thanking you for your past patronage, yours for service

EWALD BROS. SANITARY DAIRY

Cherry 2901 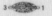 *Cherry 3470*

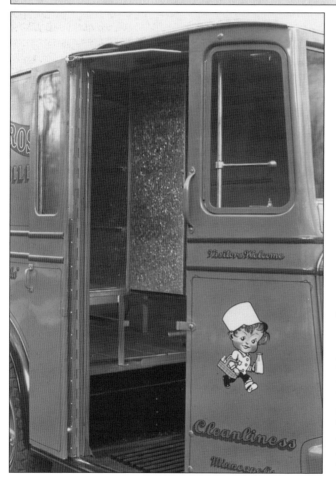

In 1923, the Minnesota legislature passed the "one day's rest in seven" law, which required employers to provide a day off within a full seven-day workweek. To provide the freshest dairy products, Ewald Bros. Dairy produced its milk seven days a week. Acknowledging adherence to the new law, Ewald Bros. Dairy communicated changes like this to their customers through mass mailings of postcards.

The Ewald family went to great lengths to promote their commitment to cleanliness. A character, named "Sunny Jim," was developed to help children identify Ewald products. For decades, Sunny Jim promoted not only Ewald products but also local stories every Tuesday morning in the "Sunny Jim on the Route" column in the *Minneapolis Star Tribune*. "Visitors Welcome" was placed on every truck to encourage people to stop by the creamery for a visit.

Ewald children modeled in the company's advertisements to appeal to mothers and fathers. Pictured are two of Ray's children, Graydon and Pat, enjoying a glass of milk. Graydon would grow into an executive role with the dairy and work his entire career for the family. Pat would eventually marry Douglas Jacobsen, who joined the dairy as a milkman but later moved to an office job. (Courtesy Norton & Peel.)

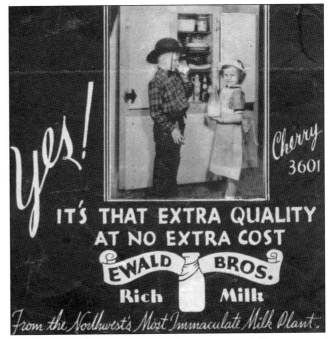

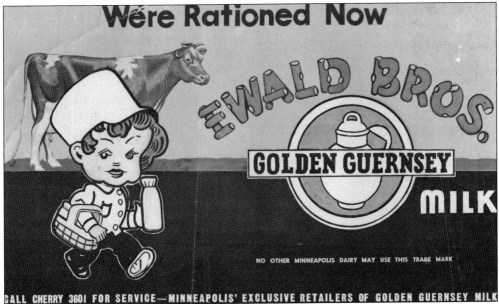

Ewald Bros. Dairy became part of the mandatory rationing initiated by the federal government in 1942. In addition to the many mechanical items such as steel, rubber, and textiles, dairy and meat products were also rationed. The typical weekly rationing for an adult was two ounces of butter, two ounces of cheese, four ounces of margarine, three pints of milk, and one fresh egg. The federal rationing program was put in place to stabilize commodities; this also allowed the government to control supply and demand. Rationing was initially introduced to avoid public anger with shortages and to prevent only the wealthy from purchasing precious commodities. Ewald Bros. Dairy carefully managed this program by verifying family sizes through the census and issuing war rationing coupon books.

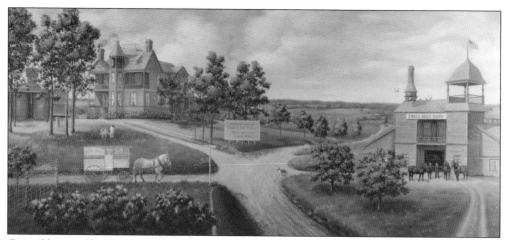

Once Chris and his family outgrew the nearly 700-acre McNair farm and built their first creamery in 1920, the farmland was divided into single-homestead parcels, which were the fastest-selling pieces of real estate in the city. As of 1921, the parcels in the first phase of development of the McNair farm were fully sold out, but there was still a demand for land, so realtors opened the second phase in 1923. The original farm is captured in this oil painting, which hung inside the Ewald creamery offices.

The Ewalds' creamery in the early 1940s was a North Minneapolis bus stop for many folks waiting to catch a ride into Minneapolis or St. Paul. The location of the dairy also meant that many schoolchildren would wait in the shadows of the dairy for their bus. This early 1930s image shows a woman waiting outside the creamery. Anyone who visited the creamery or waited outside the building would recall the constant distinct noise of rolling conveyers.

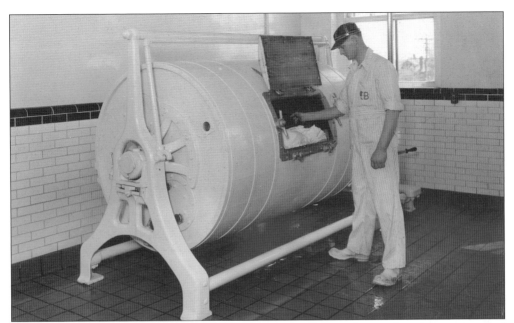

Butter churning was always done inside the creamery by a well-trained team of employees committed to producing butter to the standards Chris Ewald brought from Denmark. Danish Pride was the label for this sweet, smooth butter.

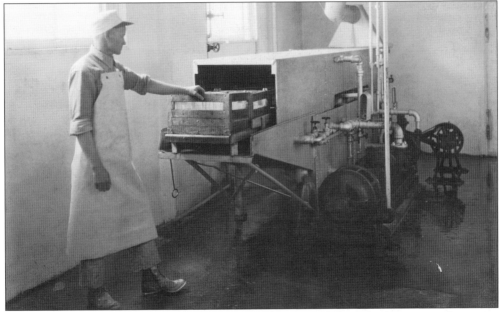

Failure in any aspect related to food safety would have significant ramifications and negative publicity that the Ewalds could not afford. Therefore, Ewald Bros. Dairy invested in the most modern bottle washing and sanitation equipment available to dairy operators. Bottles had a lifespan of about eight trips before they either broke or were discarded by the dairy, and this meant proper sanitation between uses. Shown is an automated bottle sanitizer that was continuously upgraded to meet the growing demands of sanitation. It was later replaced by massive equipment that ensured proper sanitation throughout the dairy.

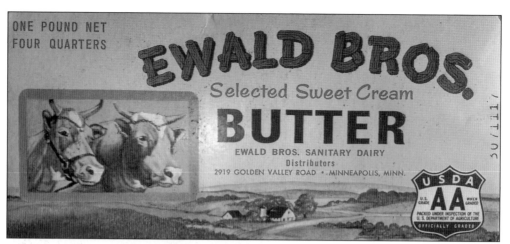

ONE POUND NET
FOUR QUARTERS

EWALD BROS.
Selected Sweet Cream
BUTTER
EWALD BROS. SANITARY DAIRY
Distributors
2919 GOLDEN VALLEY ROAD • MINNEAPOLIS, MINN.

USDA
AA
U.S. GRADE — WHEN GRADED
PACKED UNDER INSPECTION OF THE
U. S. DEPARTMENT OF AGRICULTURE
OFFICIALLY GRADED

MOVING
PICTURE
OF
HEALTH!

Remember!

You can scrub fruits
and vegetables, but ...

You Can't Wash Milk!

EWALD BROS. Rich Milk is pro-
duced on inspected farms and
delivered to you from "the most
immaculate milk plant in the
Northwest,"

at No Extra Cost!

Ewald Bros. Dairy
originally offered butter
only in returnable crocks;
however, they eventually
sold the butter in cartons.
The crocks were expensive
and heavy. The butter
cartons changed with
the consumers' demands.
For example, butter was
originally delivered in solid
one-pound blocks, but
eventually, it was packaged
into four quarter-pound
sticks for convenience.

"Remember! You can scrub
fruits and vegetables, but
... You can't wash milk!"
Ewald Bros. Dairy promised
its costumers that its milk
was produced on inspected
farms and delivered from
"the most immaculate milk
plant in the Northwest."

Transitioning from glass milk bottles to cartons was a process that took the Ewalds' customers years to adapt to. Ray was hesitant to make a full transition, as the hallmark of Ewald Bros. Dairy milk was the slight yellow tint indicating the high butterfat in the rich Guernsey milk. Eventually, the lighter, less-expensive cartons were fully adopted. The carton's earliest version was in the shape of a cone, which manufacturers thought consumers would equate with the former shape of the bottles. Unfortunately, the cone-shaped bottles were short-lived due to the pressure of the milk popping the lids off each time the crates were set down.

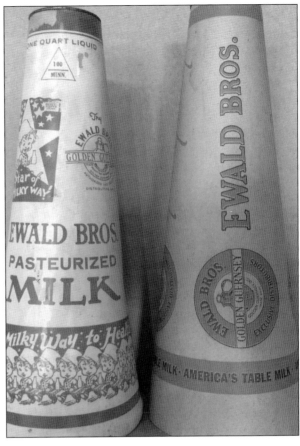

Following the demise of the cone-shaped cartons, Ewald Bros. Dairy quickly transitioned to square half-gallons. The cartons were purchased locally at Liberty Carton in St. Paul, and often were changed to reflect the seasons or to show support for local events. Gallon cartons as well as quarts, pints, and half-pints were added later for the convenience of the consumers.

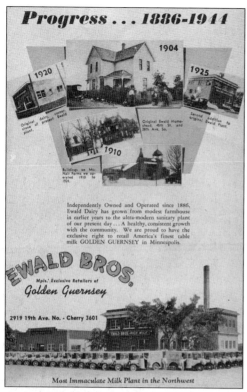

Progress ... 1886-1944

1920

1904

1925

1910

Original dairy, present Ewald plant.

Original Ewald Homestead, 45th St. and 28th Ave. So.

Second addition to original Ewald Plant

Buildings on McNair Farms we operated 1910 to 1924.

Independently Owned and Operated since 1886, Ewald Dairy has grown from modest farmhouse in earlier years to the ultra-modern sanitary plant of our present day ... A healthy, consistent growth with the community. We are proud to have the exclusive right to retail America's finest cable milk GOLDEN GUERNSEY in Minneapolis.

EWALD BROS.
Mpls.' Exclusive Retailers of
Golden Guernsey

2919 19th Ave. No. - Cherry 3601

Most Immaculate Milk Plant in the Northwest

This ad shows the progress of the independently owned and operated Ewald dairy from a modest farmhouse to an ultra-modern sanitary dairy from 1886 to 1944. Communicating these developments was something the Ewalds insisted on to not only better compete with local dairies but also to reassure consumers that Ewald Bros. Dairy was state of the art. The bulk of Ewald Bros. Dairy print advertising was done with the *Minneapolis Star Tribune*, with many other ads in professional and amateur sports programs as well as church and other civic organization bulletins.

Installing up-to-date dairy equipment was a key to the Ewalds' early success. The Ewalds continuously reinvested in the sanitation equipment and insisted on exceeding the standards of the inspectors. This equipment was often featured in the company's advertising and was certainly visible during the frequent tours. The high-gloss enamel and tiled floor were constantly washed and sanitized throughout the day to further ensure cleanliness. (Courtesy Norton & Peel.)

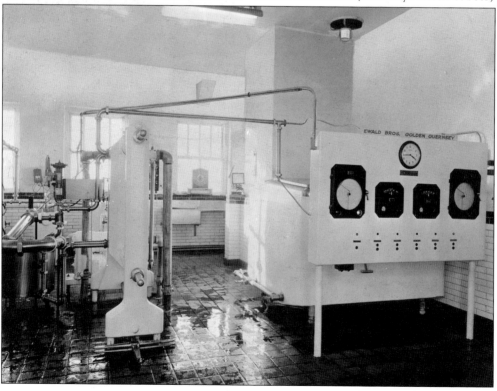

Ewald Bros. Dairy creamed cottage cheese was available in half-pints, pints, and quarts. Gallon containers were offered to restaurants, and even larger containers were delivered to schools and other institutions. The home consumers throughout the years saw cottage cheese come in a variety of different containers ranging from clear crystal glasses to plastic cups. Sales of cottage cheese would increase during promotional events as the consumers would increase consumption to fill out their cupboards with new reusable containers.

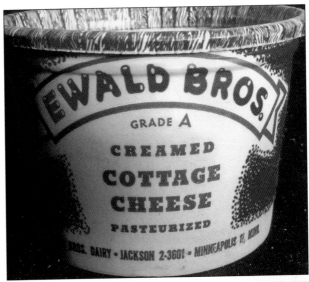

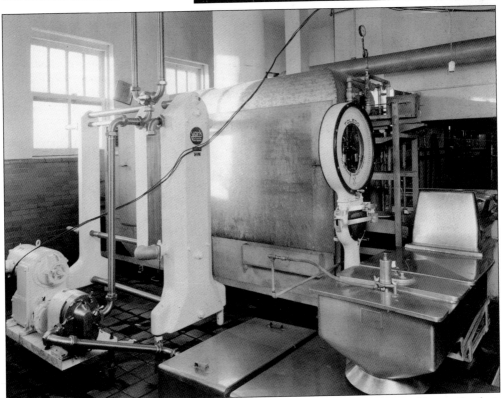

Toledo dairy scales were the premier brand of scales used by the larger dairies. Known for their accuracy and reliability, these scales were used at the Ewald Bros. creamery to weigh the eight-gallon cans brought in by farmers. Slight variations in the weight of the canisters were carefully recorded, as every ounce needed to be accounted for. When the Ewalds reviewed their pricing used to bid on home delivery, retail, and wholesale accounts, they carefully considered the numerous costs involved. Many accounts were won or lost on one tenth of a cent per pint, making accurate weighing of the incoming product very important. (Courtesy Norton & Peel.)

EWALD BROS.
Rich Milk

Standards of High Quality
Since 1886

Served Exclusively in North High School

Ewald Bros. Dairy supported the schools that provided its milk to their students. Here is a 1932 North Minneapolis High School yearbook ad featuring the very recognizable Sunny Jim. Many of the Ewald children attended North Minneapolis High School. The school contracts of Minneapolis were highly sought after by the area dairies, and Ewald Bros. Dairy won the majority of them.

Sealright hoods and caps were considered by the entire dairy industry to be the gold standard of milk bottle protection. Ewald Bros. Dairy spared no expense in committing to this program and installing the equipment. With Sealright executives on hand to ensure the process was properly functioning, the Ewalds were assured their customers would receive the safest, most sanitary milk on the market.

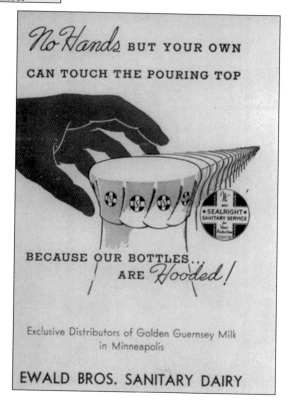

No Hands BUT YOUR OWN CAN TOUCH THE POURING TOP

BECAUSE OUR BOTTLES... ARE *Hooded!*

Exclusive Distributors of Golden Guernsey Milk in Minneapolis

EWALD BROS. SANITARY DAIRY

Cleanliness was a theme frequently used throughout Ewald Bros. Dairy's original marketing plans. This advertisement ran frequently in women's magazines to reach the targeted audience.

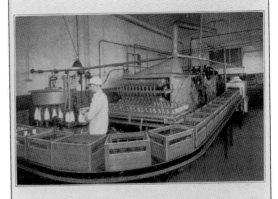

Cleanliness-"For Baby's Sake"

OUR policy of giving the fullest publicity to recognized requirements for high quality milk serves as a bond for the faithful performance of our contract with customers, and it will always be our pledge to guard the Cleanliness, Richness, and Purity of Ewald Bros. Milk and Cream from its original source on the farms until it reaches your table.

The above photograph shows one care taken in our plant, that of cleansing the bottles. Here bottles are subjected to eighteen minutes of soaking, washing, sterilizing, rinsing, and cooling. Twenty seconds after being discharged from this washer they are filled with Clean, Wholesome, Rich Milk, and then labeled.

EWALD BROS. RICH MILK

The Ewald family was extremely proud of their creamery and rightfully so, for it cost a lot to keep up to date. Among the largest pieces of equipment in the creamery were the milk storage tanks that held the raw milk from the 60 neighboring farmers. These massive vessels held 8,000 gallons each and were located on the second story of the operation. Using heavy enameled white paint or stainless-steel tanks on tiled floors made for easier cleaning. (Courtesy Norton & Peel.)

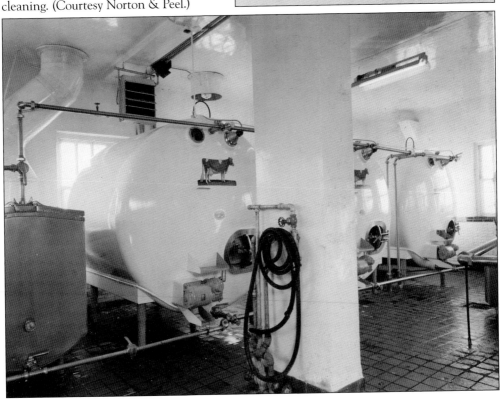

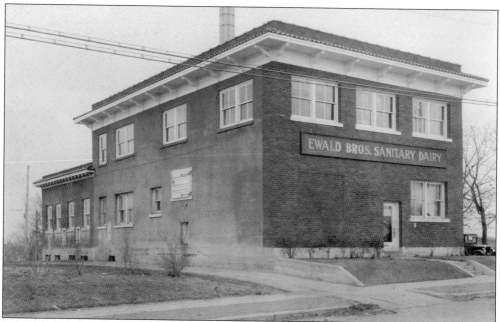

Ewald Bros. Dairy expanded its building in 1928 and converted the second story to house offices. The lower level was expanded for milk production. Once the dairy had been fully expanded in the 1960s, the bottling room and conveyers were located on the lower level with the milk flowing down from the upper-level pasteurization tanks on the second floor. The farmers would arrive at the creamery and the raw milk from the eight-gallon cans would be pumped upstairs through pristine stainless-steel pipes into the processing rooms before being returned to the lower level for bottling.

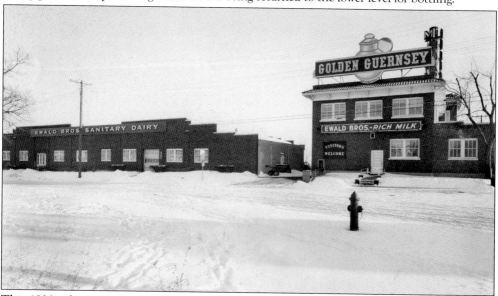

This 1930s photograph shows the creamery after a few additions were made to the building. Note the detached garage to the left; it was used to store the fleet. A loading area was available between the two buildings. There, the milkmen would load their trucks with the help of outdoor conveyers. A new two-story garage would soon be built, and the existing garage became attached to accommodate refrigeration and loading. (Courtesy Norton & Peel.)

The year 1961 marked the Ewald Bros. Dairy's 75th anniversary. The state of Minnesota, city of Minneapolis, and the many organizations affiliated with the Ewalds celebrated this milestone. Perhaps the most special gift commemorating the anniversary was from the employees; they gave a bronze plaque to be displayed at the entrance of the creamery.

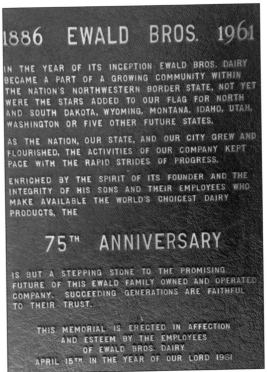

1886 EWALD BROS. 1961

IN THE YEAR OF ITS INCEPTION EWALD BROS. DAIRY BECAME A PART OF A GROWING COMMUNITY WITHIN THE NATION'S NORTHWESTERN BORDER STATE, NOT YET WERE THE STARS ADDED TO OUR FLAG FOR NORTH AND SOUTH DAKOTA, WYOMING, MONTANA, IDAHO, UTAH, WASHINGTON OR FIVE OTHER FUTURE STATES.

AS THE NATION, OUR STATE, AND OUR CITY GREW AND FLOURISHED, THE ACTIVITIES OF OUR COMPANY KEPT PACE WITH THE RAPID STRIDES OF PROGRESS.

ENRICHED BY THE SPIRIT OF ITS FOUNDER AND THE INTEGRITY OF HIS SONS AND THEIR EMPLOYEES WHO MAKE AVAILABLE THE WORLD'S CHOICEST DAIRY PRODUCTS, THE

75TH ANNIVERSARY

IS BUT A STEPPING STONE TO THE PROMISING FUTURE OF THIS EWALD FAMILY OWNED AND OPERATED COMPANY. SUCCEEDING GENERATIONS ARE FAITHFUL TO THEIR TRUST.

THIS MEMORIAL IS ERECTED IN AFFECTION AND ESTEEM BY THE EMPLOYEES OF EWALD BROS. DAIRY APRIL 15TH IN THE YEAR OF OUR LORD 1961

The Ewald brothers continued to expand their dairy to accommodate the growing needs of the business. Local Minneapolis contractors were always hired to complete the renovations. In many cases, second-generation contractors worked on what had previously been built by their fathers. The dairy had now joined the garage and the main building with a tunnel for trucks to pass through and load. (Courtesy Norton & Peel.)

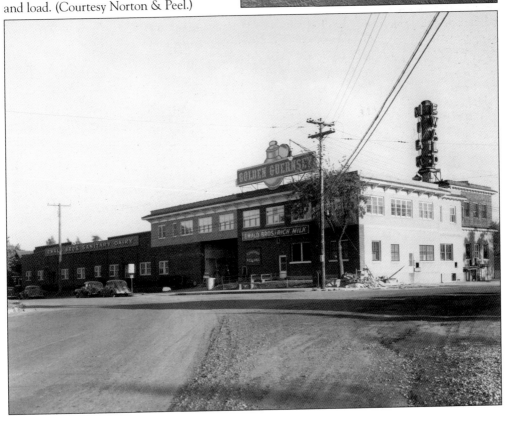

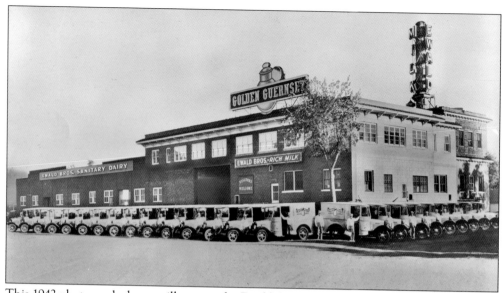

This 1942 photograph shows milkmen at the Ewald dairy. Beginning as a single-story structure in 1920, the dairy eventually grew to the size of two city blocks with two stories. Located at 2919 Golden Valley Road, the Ewald dairy was a landmark on the city limits of both Golden Valley and North Minneapolis. (Courtesy Norton & Peel.)

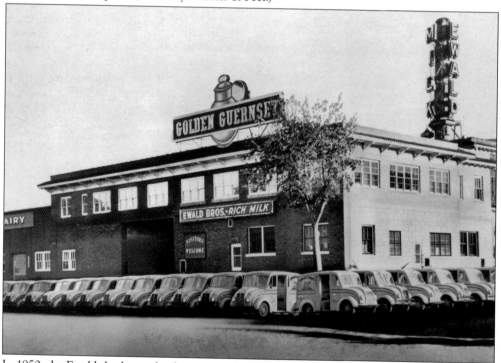

In 1950, the Ewalds had completely converted to Divco trucks. With an additional 15 wholesale trucks, the Ewalds promoted their new modernized fleet extensively, as the delivery vehicle was as important to the family as the products they sold. With a very dedicated team of mechanics keeping the trucks running, the milkmen encountered very few breakdowns that could not be fixed on the spot. (Courtesy Norton & Peel.)

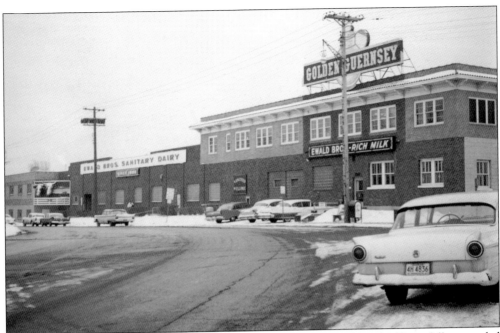

Ewald Bros. Dairy's heyday was in the late 1950s. At that point, the building had been fully expanded and was unable to expand any farther. The lack of room to grow would become increasingly more important in the years to come when milk was no longer produced in cartons but in plastic bottles. The introduction of the new recyclable plastic bottle had a significant impact on Ewald Bros. Dairy's bottom line as they were forced to outsource these bottles at a higher cost than the dairy could produce its own bottles. (Courtesy Douglas Jacobsen.)

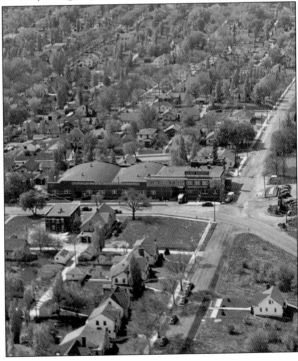

This 1954 aerial photograph of the Ewald dairy, taken by Ray Ewald's son-in-law and milkman Douglas Jacobsen, shows the magnitude of the dairy in relationship to its neighborhood. The plant shown here is at 2919 Golden Valley Road in North Minneapolis, with parking to the west in Golden Valley. Many of the Ewalds' homes were within walking distance of the dairy to the north of the building. Out of range of this photograph is the enormous stable that was northeast of the creamery. (Courtesy Doug Jacobsen.)

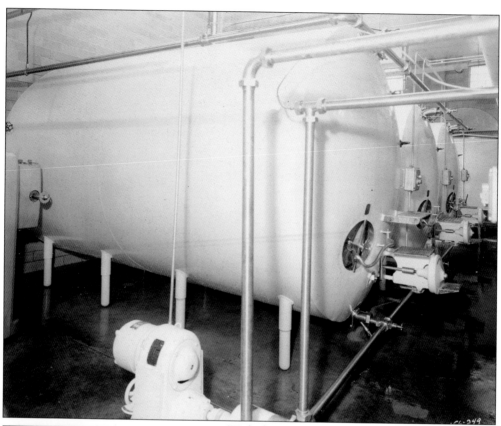

With the numerous expansions to the dairy came the need for additional storage tanks. Ewald Bros. used tanks exclusively for Golden Guernsey milk as required by the Golden Guernsey association as well as separate milk holding tanks for their Rich Milk brand. Both brands had dedicated lines running up to the storage tanks from the lower-level receiving area and then back down to the bottling room. (Courtesy Norton & Peel.)

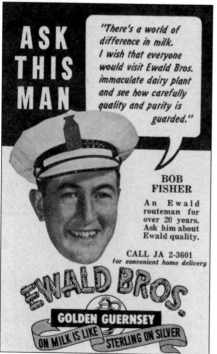

Bob Fisher was one of the more recognizable milkmen due primarily to his frequent appearances in the Ewalds' advertising. Bob was a kind and generous milkman and served all his customers with a smile. The Ewalds were extremely proud of all their employees and featured many of them in their weekly ads.

48

Three

THE FINEST NAME IN MILK

"Our milk has to be the best—our name is on every bottle." Ray Ewald said that often. He also stated, "It's great to have a friend to open a door for you but if you want that friendship to last you'd better carry top quality products through their door." Danish Pride is what the Ewald family called its buttermilk, and that not only described the product but also the company's commitment to superior quality in all of its products.

To promote these products, the Ewald family looked for partnerships that would help carry their message of quality, and so they reached out to several promising advertising companies.

In the early 1940s, a young man named Robert Naegele met with Ray Ewald, then owner of Ewald Bros. Dairy. Naegele had an idea that he thought could sell a lot of milk. He proposed a large sign that looked just like Guernsey cows, and thus began a friendship that would lead to one of America's largest outdoor advertising companies and Minnesota's largest home-delivery dairy. Robert Naegele enlisted the support of famed Robbinsdale, Minnesota, artist Bob Johnson to bring the concept to reality, and for decades, the beloved cows stood watch over Minneapolis and its suburbs. The original pair of cows now have a permanent residence on the grounds of the Minnesota State Fair.

WCCO radio of Minneapolis became another advertising conduit that helped the Ewalds convey their message in the form of jingles that still are fondly remembered. The late Cedric Adam of WCCO, a popular late-night personality, was particularly fond of the Ewald Bros. and served as the on-air spokesperson for over 30 years.

Perhaps the most significant relationship Ewald Bros. Dairy formed was an exclusive partnership with Golden Guernsey. This national brand became exclusive to Ewald Bros. Dairy in Minneapolis and clearly helped separate them from the other home-delivery dairies. With a strong national reputation for brand recognition and quality, Golden Guernsey helped Ewald Bros. carry their message on almost every piece of advertising from the early 1930s until 1970.

A Family-owned
Independent Dairy Since 1886

The Golden Guernsey brand gave the Ewalds many unique advertising opportunities as the exclusive Minneapolis distributorship. Golden Guernsey Inc. provided them with extensive support in terms of formatting advertising and sharing costs. Many dairies at that time did not have a value-added brand to differentiate themselves from their competitors, and Golden Guernsey's investment in Ewald Bros. influenced the dairy's longevity. The Ewalds developed the slogan: "Golden Guernsey on milk is like Sterling on silver."

Throughout its history, consumers have interpreted the *Good Housekeeping* seal of approval to be an indication of a very good product. The purpose of the *Good Housekeeping* seal was to serve the needs and interests of the homemaker in a way that no other institution of its kind ever had. The Ewalds applied for approval in the early 1920s and relentlessly adhered to the strict guidelines of the *Good Housekeeping* organization. They successfully earned the endorsement during their first year of application and never once lost the endorsement.

War-theme advertisements were printed when rationing needed to be emphasized. This one reads in part, "While we are at war with foreign foes, let's not forget the foe at home." Ewald Bros. Dairy wanted to reiterate their commitment to sanitation with this ad. The gold standard of bottle protection, Sealright ensured the safety of the company's milk. This milk cap was placed on the bottle while the rim was still sterile, keeping the rim sterile, clean, and tamper-proof until the homeowner broke the seal.

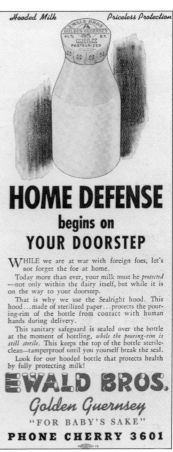

Hooded Milk · Priceless Protection

HOME DEFENSE
begins on
YOUR DOORSTEP

WHILE we are at war with foreign foes, let's not forget the foe at home.

Today more than ever, your milk must be *protected* —not only within the dairy itself, but while it is on the way to your doorstep.

That is why we use the Sealright hood. This hood...made of sterilized paper...protects the pouring-rim of the bottle from contact with human hands during delivery.

This sanitary safeguard is sealed over the bottle at the moment of bottling, *while the pouring-rim is still sterile*. This keeps the top of the bottle sterile-clean—tamperproof until you yourself break the seal.

Look for our hooded bottle that protects health by fully protecting milk!

EWALD BROS.
Golden Guernsey
"FOR BABY'S SAKE"
PHONE CHERRY 3601

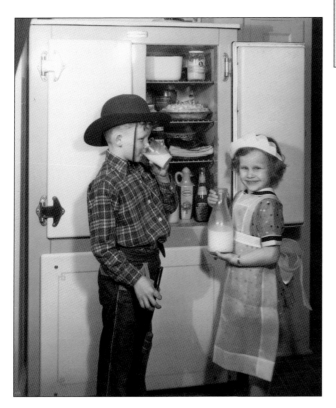

If the Ewald Bros. Dairy's products were safe enough for the Ewalds' children, the products were safe enough for consumers' children. Graydon Ewald started starring in Ewald ads as young as two years old, while Pat made her debut at age six. Douglas Ewald was used as a model from his infancy through his teen years. Graydon and Pat, pictured here with an icebox, which was cooled with ice and required twice-daily stops from the milkman to ensure the dairy products were as fresh as possible.

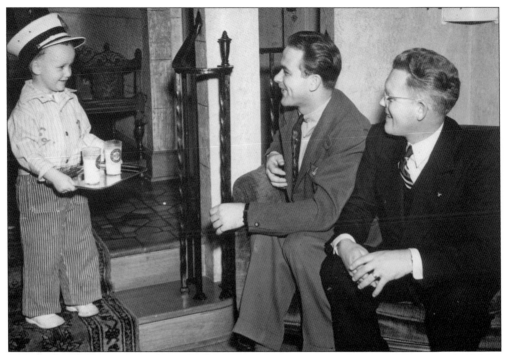

Douglas Ewald, in a custom uniform for Ewald Bros. Dairy, promotes the new affiliation with Golden Guernsey by serving up a couple of fresh glasses to Golden Guernsey promotions representative Daryl Brady and Doug's father, Ray. Doug acquired a few custom uniforms over the years, which he wore in Ewald advertisements. Ewald Bros. purchased its uniforms in Minneapolis and frequently updated them. (Courtesy Schoen-Klammer studio.)

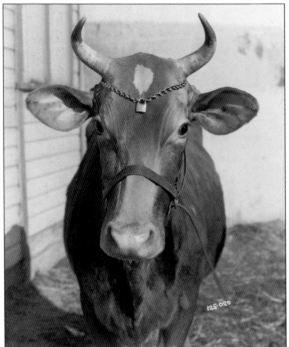

In the beginning of the Ewald Bros. Dairy, the Ewald boys and their single farmstead produced all the milk the dairy needed for its customers and the family. However, as the routes continued to grow, Chris was forced to add certified Guernsey farms to satisfy the growing demand on the dairy. With the McNair farmland locked at 700 acres, it was eventually sold, and the Ewalds concentrated on processing and distributing Golden Guernsey milk from almost 60 farms within a two-hour commute to the dairy. The commute was required to be two hours or less to ensure freshness of the product. Shown here is a cow with the trademark locket on her forehead; the locket was required by the American Breeders association to certify each farm and the quality of the milk. (Courtesy Norton & Peel.)

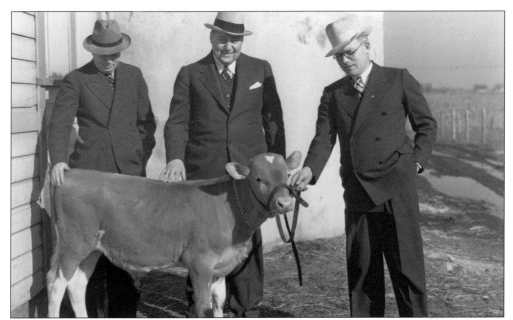

Once the Ewald family was no longer able to produce enough milk for the customers, it was decided to outsource the milk to Golden Guernsey–certified farmers. Shown here on February 2, 1938, are, from left to right, an unidentified licensing inspector from Golden Guernsey, Arthur Gluek, and Ray Ewald. The Gluek family was most notable for producing the very popular Gluek beer, as well as running large-scale dairy farms throughout Minneapolis and its suburbs. (Courtesy Norton & Peel.)

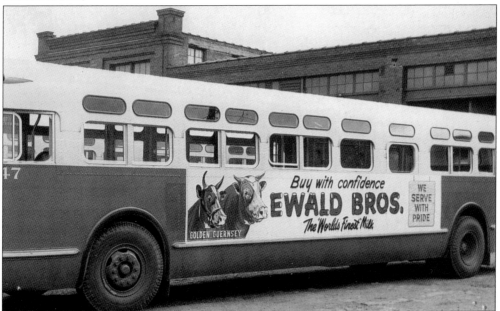

Mass transportation was extremely popular during the late 1940s to 1950s. Many people used busses as their primary means of transportation to work, shopping, and visiting. Ewald Bros. Dairy partnered with the well-known bus company Houck Transit to develop advertising for the bus sides, which remain popular places to advertise today. (Courtesy Houck Transit.)

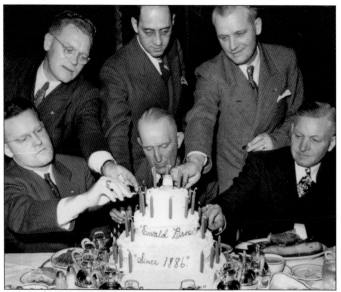

Ewald Bros. Dairy celebrated its anniversary each April with a special dinner for employees and their spouses. These anniversary dinners were broadcast live on the radio by WCCO's Cedric Adams and always included the governor of Minnesota and others. Shown at the 56th anniversary are, from left to right, (first row) Donald Ewald, Andrew Burns, and Robert Ewald; (second row) Ray C. Ewald, Mayor Kline, and Dewey S. Ewald. Burns was the senior employee at the time, with 32 years at the dairy.

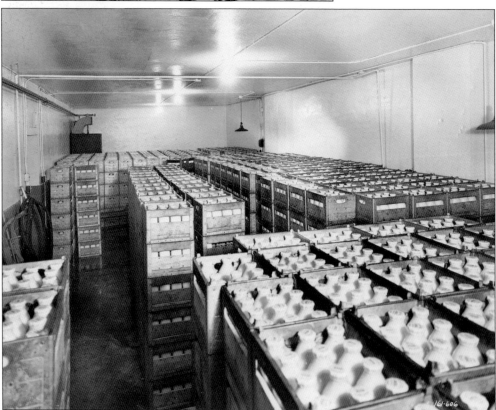

Ewald Bros. Dairy had numerous coolers strategically located near the lines of conveyers throughout the creamery. Workers flash-cooled the milk in under 28 seconds after pasteurization and homogenization. Once processed, the milk was immediately bottled in sterilized Sealright-protected bottles and loaded in the waiting coolers to be placed on retail trucks. These bottle rooms typically held over 20,000 quarts of milk. (Courtesy Norton & Peel.)

Cedric Adams, a larger-than-life radio personality for WCCO, is shown here enjoying a glass of Ewald Bros. Dairy's Golden Guernsey milk on July 8, 1951, with one of the Aquatennials performers. Adams was employed by WCCO from 1931 until his death in 1961. Most notable was his presence at the annual Ewald anniversary parties where he broadcast his show live from the event. Often inciting gags and other pranks on the Ewald boys, Adams became a dear friend of Ray and was responsible for most of the voice-over work for Ewald Bros. Dairy's on-air advertising. (Courtesy Norton & Peel.)

Ewald Bros. Dairy used numerous opportunities to promote its partnership with Golden Guernsey to its consumers. Many unique forms of advertising were passed out to the customer through their milkman. Calendars, bridge card tallies, and toy banks, among others, were frequent favorites of Ewald Bros. Dairy's customers.

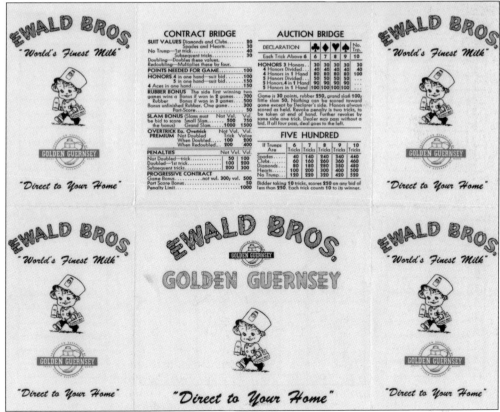

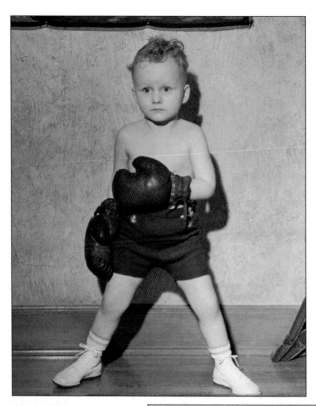

Golden Gloves boxing was a very popular sport in the 1940s due primarily to its low cost of participation and inexpensive ticket prices. Douglas Ewald is shown here with his gear. Golden Glove candidates were encouraged to participate at a very young age. (Courtesy Schoen-Klammer Studio.)

With strong brand-name recognition, Ewald Bros. Dairy used Golden Guernsey and Golden Gloves to promote their mutual brands and continued to have youths in their advertising. Recognizing the importance of this demographic was a key marketing vehicle for the Ewalds throughout the years.

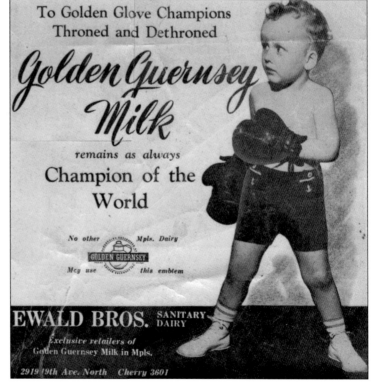

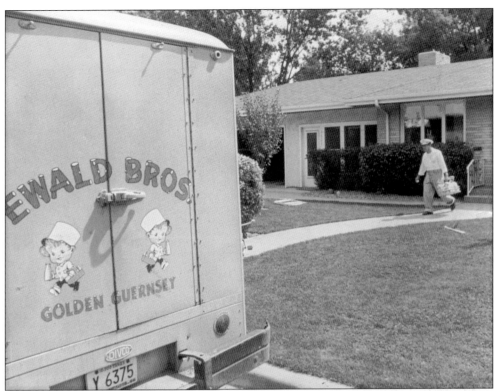

Divco was a brand name of delivery trucks primarily used for delivery of milk and bread. Built and marketed in the United States, Divco is an acronym that stands for Detroit Industrial Vehicle Company. Divco became known for its multi-stop delivery trucks, particularly as home-delivery vehicles by dairy distributors. From 1926 to 1938, Ewald Bros. Dairy switched its entire fleet over to Divcos, with the exception of their larger commercial vehicles.

Robert "R.O" Naegele was a lifelong friend of Ray Ewald and had started a small outdoor advertising company. He came up with the idea of the Guernsey cow billboards to help promote the dairy. The initial meeting between Naegele and Ray at the dairy resulted in a decades-long advertising campaign that built not only a dairy but also an outdoor sign company. Naegele's first billboard for Ewald Bros. was a massive Golden Guernsey cow that stood atop the well-known Rainbow Café in Uptown Minneapolis for decades. (Courtesy Naegele family.)

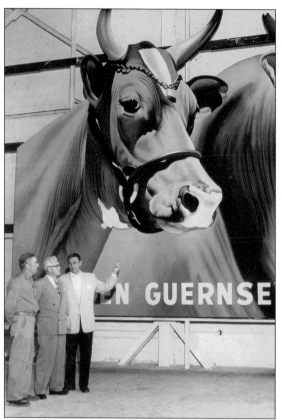

Ewald Bros. Dairy used many formats of outdoor advertising with nationally recognized Naegele Outdoor Advertising. Here, Naegele artist Lee Wilfong is shown with Ray Ewald and Robert Naegele admiring a freshly painted sign. Ewald Bros. was the very first customer of Naegele's and helped the young sign company grow. (Courtesy Wilfong family.)

Bob Johnson (1923–2016) forever changed outdoor advertising with his multidimensional art that spanned Minneapolis landmarks for over 60 years. Perhaps best known for his work with Ewald Bros. Dairy and Naegele Outdoor Advertising developing the massive Guernsey cows that jutted out from the billboards, Johnson was also instrumental in developing floats for the annual Orange Bowl in Miami along with numerous other Twin City attractions. The Guernsey cows were enormous and required that Johnson work out of a rented aircraft hangar to construct them. (Courtesy Bob Johnson family.)

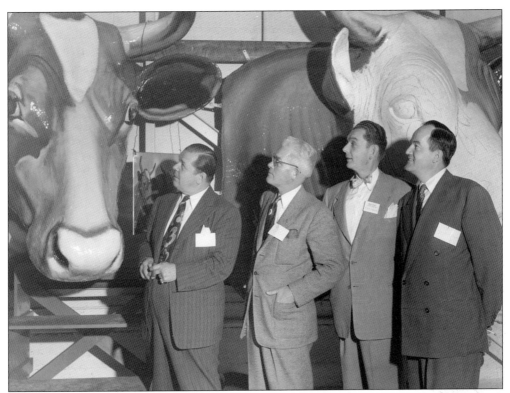

Pictured on August 16, 1947, from left to right, are Charlie Saunders, Ray Ewald, Bob Naegele, and Hubert Humphrey. Saunders was the founder of the popular Minneapolis restaurant Charlie's Café. Robert Naegele was the founder of Naegele Outdoor Advertising. Ray Ewald was president of Ewald Bros. Dairy, and Hubert Humphrey was the mayor of Minneapolis. Humphrey went on to eventually become vice president of the United States. (Courtesy Naegele family.)

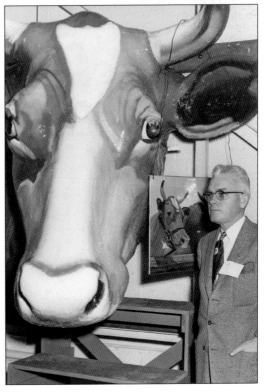

Ray Ewald stands with a newly completed sign. Ray was originally opposed to the concept of the 3-D signs developed by Bob Johnson and Robert Naegele, and he initially planned to decline the opportunity. Naegele reached out to Bob Johnson and instructed him to build them anyway and said that "Ray would love them once he saw the finished work." Johnson completed the first set in the 1940s, and from that point on through Ray's life, the billboards were used throughout the cities. (Courtesy Naegele family.)

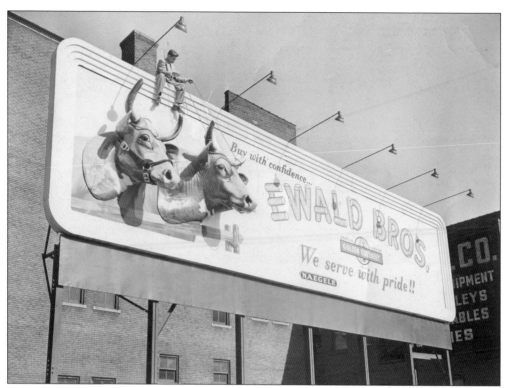

Bob Johnson, creator of the 3-D Golden Guernseys, sits high atop a newly installed billboard in Downtown Minneapolis. Johnson had built numerous sets of these bovines and personally oversaw the final installation of the Naegele billboard signs. Here, he places the finishing touches on a pair of horns prior to their being permanently put in place. This sign was one of the mid-sized billboards that Ewald Bros. Dairy and Naegele placed in non-freeway areas. (Courtesy Naegele family.)

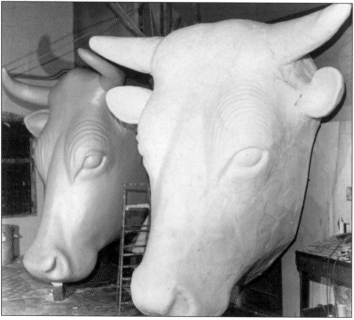

Showing the true scale of the billboards, this pair of Golden Guernsey cows is sitting in an aircraft hangar while work is completed. Built from wooden frames and then covered with fiberglass, these sculptures took months to complete but would last for decades with annual maintenance conducted by Bob Johnson.

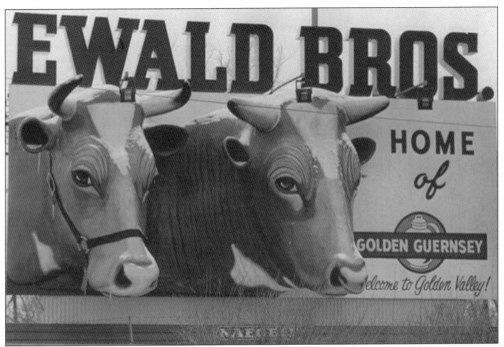

This 1948 photograph shows a newly completed billboard directly across from the Ewald dairy; it welcomed citizens to Golden Valley. This billboard was later purchased by the Minnesota State Fair. (Courtesy Naegele family.)

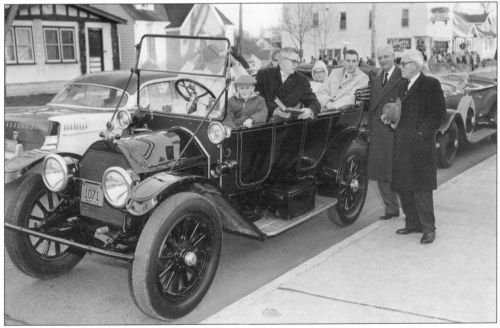

A 1911 vintage automobile was the perfect ride to commemorate the year when the Ewald boys moved their herds across town from South Minneapolis to Golden Valley. Driving the car is Graydon Ewald, with some of his children riding. Standing next to the vehicle are Dewey (left) and Ray Ewald. (Courtesy Bruce Sifford Studio.)

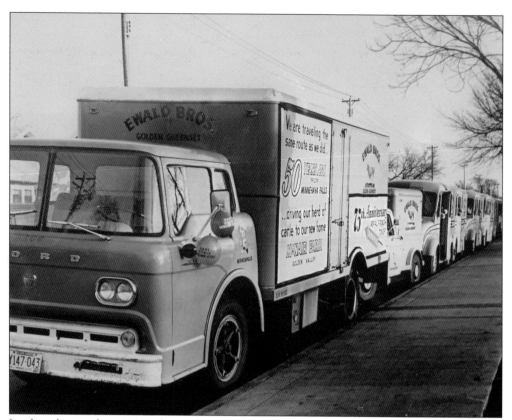

Leading the parade in 1961 is the Ford C-600, the original workhorse of the Ewald fleet. Known for its durability, these trucks lasted for decades with the fleet. This truck was one of 50 commemorating the journey that Chris and John Ewald made with their herd from South Minneapolis to their new home on McNair farm. Following in this parade are 50 Divco trucks representing the 50th anniversary of the journey. (Courtesy Norton & Peel.)

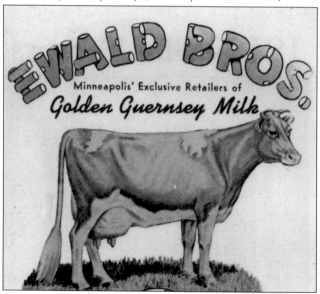

Guernsey cows are among the more recognizable cattle due to their distinct coloring of tan and white. The cows are known to have a calm demeanor. The Guernsey cows were featured on the sides of the Ewalds' Divcos for decades and were frequently used throughout their advertising and other promotional items.

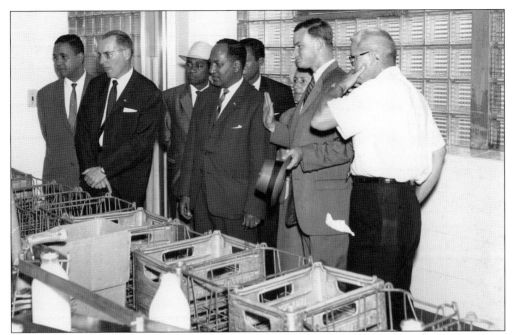

The Ewald Bros. Dairy's commitment to others often went outside the city limits into other states and countries. Studying milk production was a popular and valuable lesson provided to dairies that needed the visual resources of a fully functioning, highly proficient operation. In many cases, the lessons learned inside the immaculate creamery were taken home and used within the visitors' facilities. Throughout the years, Ewald Bros. Dairy also entertained visiting students from grade schools to universities to study milk production. (Courtesy Bruce Sifford Studio.)

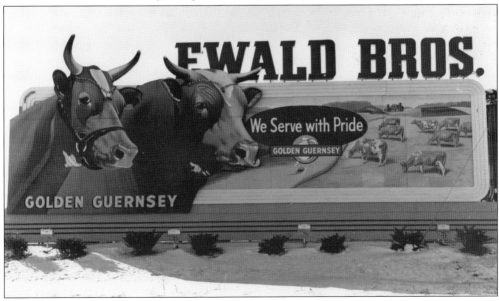

Getting beyond the dimensions of a standard billboard, measuring typically 14 by 48 feet, Naegele would go above the sign space to drive a message home. Using the enormous silhouettes of cows or the Ewald name spelled out provided two opportunities for passersby to take notice, either from the front side or from the back. (Courtesy Naegele family.)

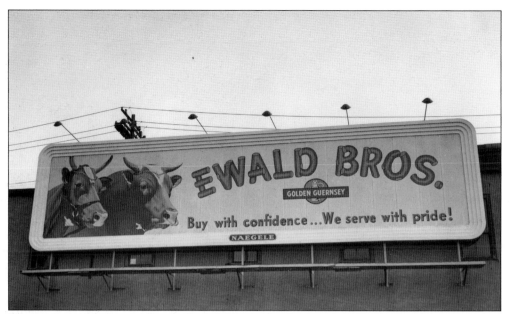

"Buy with confidence, we serve with pride" was a familiar message for the Ewald family to their customers and potential customers. This slogan was developed to continue to enforce the message that the consumer could confidently trust the dairy. (Courtesy Naegele family.)

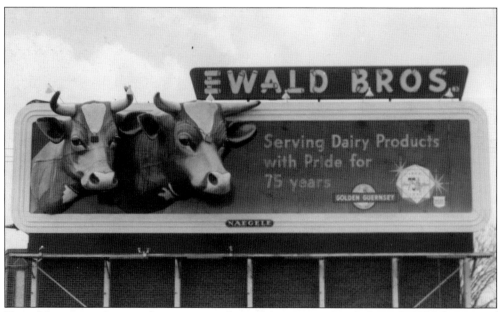

Naegele's company became the premier outdoor advertising agency in the early 1930s because of its creativity and partnering with famed artists, such as Bob Johnson, to develop 3-D advertising. In addition to the creative aspects, Naegele was among the first to develop electric features other than spotlights to illuminate their advertising. Shown here is an early 1940s billboard originally located in St. Louis Park, Minnesota, featuring one of the first neon-lighted signs that Naegele produced for Ewald Bros. Dairy. (Courtesy Naegele family.)

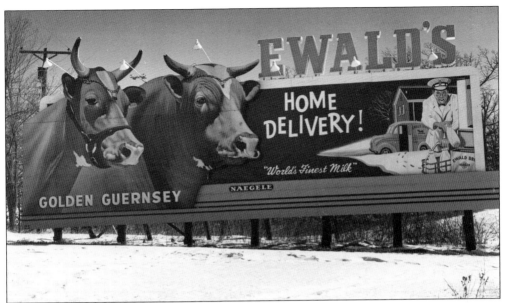

On this billboard was a hand-painted illustration that did not need text. Pictured is a milkman placing milk in a waiting porch box with his truck parked on the curb. Ewald Bros. Dairy had started to appear in supermarkets at the time of this billboard in the early 1950s; however, it continued to promote its preferred home-delivery option as well. (Courtesy Naegele family.)

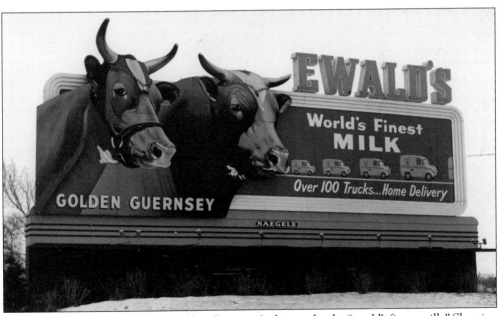

Ewald Bros. Dairy capitalized on Golden Guernsey's claim to be the "world's finest milk." Showing a fleet of trucks on this billboard conveyed the message that the company was prepared to deliver. (Courtesy Naegele family.)

Among the events sponsored by Ewald Bros. Dairy was roller derby, a very new sport to Minneapolis. The events were held in an "air-cooled" Minneapolis Auditorium. Tickets were 10¢ and were offset by the company to help attract attendees to the new sport. During the roller derby's flourishing years (1935–1937), it proved to be a valuable escape for those facing the financial hardships of the Great Depression. Discounted or free tickets were important due to the little buying power of most people at the time.

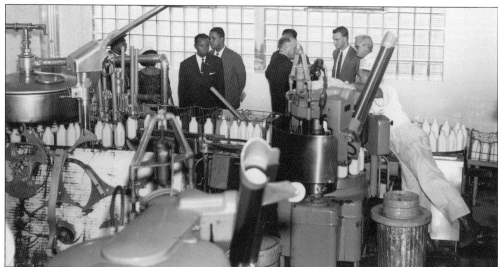

Schoolchildren, as well as many civic groups and professional organizations, loved the creamery tours. Among the most frequent visitors were the neighborhood children who, at any time, could stop by the dairy and get a drink of fresh water from the artesian well and then proceed to the bottling room for a complimentary bottle or carton of milk. The Ewald family made this investment to show that they were always open for inspection. (Courtesy Bruce Sifford Studio.)

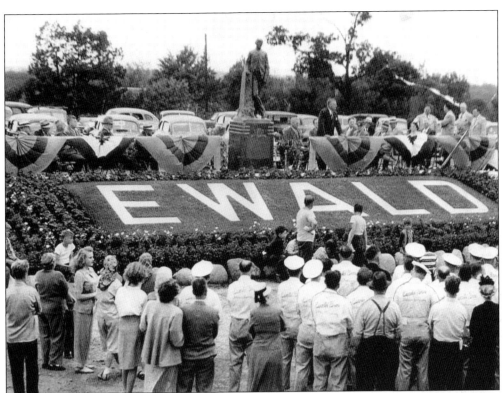

As the four Ewald brothers look on along with their families and employees on June 29, 1948, Minnesota governor Luther Youngdahl offers the opening address at the dedication ceremony of Chris Ewald's statue. The statue stood watch over the dairy and sat high atop the hills overlooking the former farmland in Golden Valley.

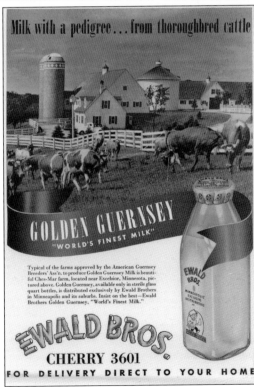

Among the many farms producing milk for Ewald Bros. Dairy was the Chester Martin Farms (Ches-Mar Farms). An American Guernsey Breeders Association–approved farm, it was beautiful and was located near Excelsior, Minnesota. Shown is the pristine farm on the shores of what is now Lake Minnetonka; the farm currently is a housing development. The Ewald Bros. Dairy featured this ad in high school yearbooks west of Minneapolis where the students would be familiar with the farm and its operators.

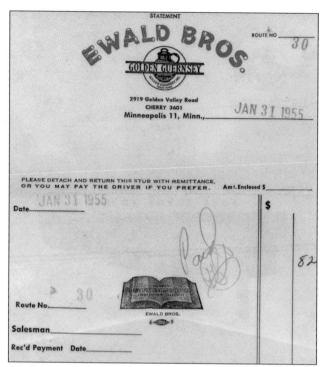

The company employed a dedicated team of office support staff and administrators to balance the accounts of over 30,000 home-delivery customers weekly along with institutional accounts, ensure orders were placed, and check milkmen in upon their return. The milkmen's routes were split into A and B sides, and each milkman ran each route every other day. The frequency of these stops meant an enormous amount of paperwork for the employees who ran the Ewald offices, especially considering it was all done before the time modern computers became widely available.

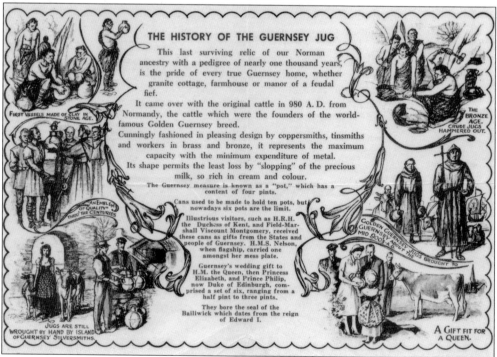

The history of the unique Golden Guernsey jug is explained in a piece of promotional advertising the Ewald milkmen provided their customers. The unique round shape of the "pot" was designed to minimize "slopping" or loss of product when being delivered. The pots were handmade precisely to hold four pints of milk.

Four

THE PEOPLE BEHIND THE BOTTLE OF MILK

The journey of a milk bottle often began at one of the farms with authorized Guernsey cattle; haulers with refrigerated stainless-steel tanker trucks picked up the milk daily, which was initially rushed to the creamery in North Minneapolis in eight-gallon cans.

From the truck, the milk was pumped to the production room, where it was pasteurized, clarified, and its butterfat modified by a technical team of plant workers to reach the desired end product. Ewald Bros. Dairy's milk ranged from 4.5 percent cream top butterfat to skim.

A maze of stainless-steel pipes ran the product downstairs, where the "inside guys" marshaled a nonstop parade of freshly sanitized glass bottles into cases and immediately whisked them into coolers. The "cooler men" worked in a steady 40-degree temperature year-round maintaining the constant flow of crates.

The freshly bottled milk and other dairy products were now chilled and ready to be loaded, but nothing happened if the trucks did not start or continue to perform throughout the day. Ewald Bros. Dairy had an extensive garage, along with a paint shop, led by a dedicated team of eight mechanics.

Once the company delivered its products, the upstairs office staff, consisting of 10 employees, paid the bills, completed payroll, and sent invoices to wholesale accounts, among many other administrative tasks. Development specialists spent time connecting with families that had recently to Minneapolis.

On the route, the company had approximately 150 deliverymen who faced Minnesota's extreme weather. Wholesale route men made fewer stops in a day, and instead of hand carriers, they wheeled countless stacks of bottles and cartons into grocery stores, schools, and restaurants—often up and down many flights of stairs.

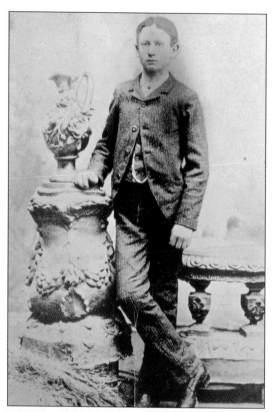

A 16-year-old Chris Ewald is pictured next to a milking post, which was used to hold the cows steady while they were milked. Chris had a true love and appreciation for his farm and livestock and often tended to them after work hours to ensure they had the best of care. Once Chris made the decision to build a new stable on Washburn Avenue in Minneapolis, he spared no expense to ensure the cows that produced the world's finest milk had the world's finest care.

This first-known image of the Ewald milkmen in 1926 illustrates the dedication of the smartly dressed men; at the time of this photograph, Ewald milkmen were known to say, "Glad to serve you." Many of them spent decades with Ewald Bros., with the longest serving 47 years. In many cases, these were lifelong jobs, and many only took time off to serve in the military during wartime.

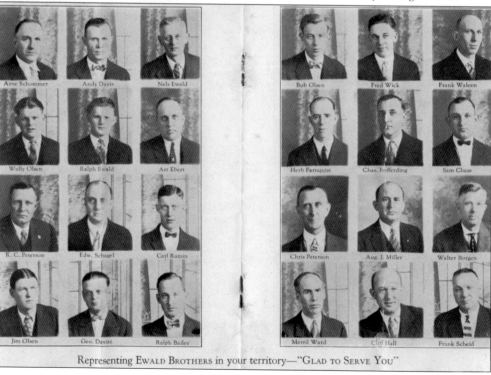

Arne Schommer | Andy Davis | Nels Ewald
Wally Olsen | Ralph Ewald | Art Ebert
R. C. Peterson | Edw. Schagel | Carl Ramin
Jim Olsen | Geo. Davitt | Ralph Bailey
Bob Olsen | Fred Wick | Frank Waleen
Herb Farnquist | Chas. Bofferding | Sam Chase
Chris Peterson | Aug. J. Miller | Walter Borgen
Merril Ward | Cliff Hall | Frank Scheid

Representing Ewald Brothers in your territory—"Glad to Serve You"

Chris Ewald and his four boys are shown in this 1926 promotional image with their current titles. Ray and Dewey would proceed through the years sharing titles and exchanging responsibilities. Dewey would focus on the inside operations of the creamery while Ray focused on building name recognition and community relations and sponsorships. Bob would manage inventory and finances, and Don would focus his efforts on the drivers.

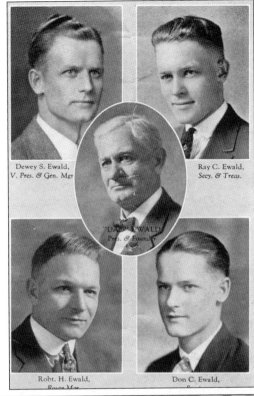

Dewey S. Ewald,
V. Pres. & Gen. Mgr.

Ray C. Ewald,
Secy. & Treas.

"DAD" EWALD,
Pres. & Founder

Robt. H. Ewald,
Route Mgr.

Don C. Ewald,

The drivers' uniforms changed frequently, but one constant that the Ewalds insisted on was a bow tie or straight tie. Keeping the uniforms impeccably clean was paramount to their success as the Ewald brothers would not deliver milk in dirty uniforms. White uniforms were perhaps the hardest to be kept clean but helped present the homeowner with a visual reminder of cleanliness. In the 1940s, the drivers said, "Happy to serve you," to their customers.

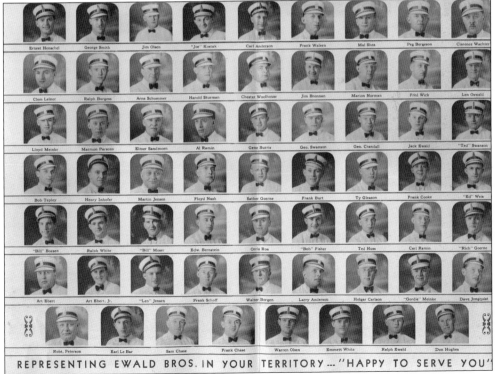

Ernest Henschel — George Smith — Jim Olsen — "Joe" Kostak — Carl Anderson — Frank Walters — Mal Shea — Peg Bergeson — Clarence Wachter

Clem Leiner — Ralph Burgess — Arne Schommer — Harold Sturman — Chester Woolhouse — Jim Brennen — Marion Norman — Fred Wick — Len Oswald

Lloyd Meinke — Marmon Parsons — Elmer Sandmoen — Al Ramin — Gene Burris — Geo. Swanson — Geo. Crandall — Jack Ewald — "Ted" Swanson

Bob Tepley — Henry Inhofer — Martin Jensen — Floyd Nash — Sather Goerne — Frank Burt — Ty Gleason — Frank Cooke — "Ed" Weis

"Bill" Boesen — Ralph White — "Bill" Moser — Edw. Bernstein — Orris Roa — "Bob" Fisher — Ted Huss — Carl Ramin — "Rich" Goerne

Art Ebert — Art Ebert, Jr. — "Len" Jensen — Frank Schoff — Walter Borgen — Larry Anderson — Holger Carlson — "Gordie" Meinke — Dave Jongquist

Robt. Peterson — Earl Le Bar — Sam Chase — Frank Chase — Warren Olsen — Emmett White — Ralph Ewald — Don Hughes

REPRESENTING EWALD BROS. IN YOUR TERRITORY..."HAPPY TO SERVE YOU"

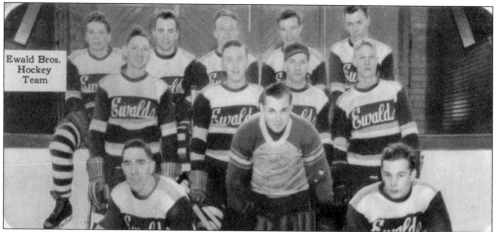

Ewald Bros. Hockey Team

Ewald Bros. Dairy employees participated in a wide variety of sports, mostly against other Minneapolis and St. Paul dairies. Hockey, diamond ball, bowling, and football were all sponsored sports provided to the milkmen.

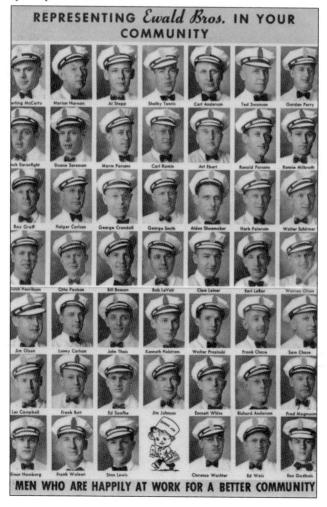

REPRESENTING *Ewald Bros.* IN YOUR COMMUNITY

MEN WHO ARE HAPPILY AT WORK FOR A BETTER COMMUNITY

"Men who are happily at work for a better community" perfectly sums up the company's commitment to community service in the 1950s. With new uniforms, again in white but with blue pinstripes, the Ewald milkmen were known to be the sharpest dressed milkmen in the city. Children of the milkmen often watched their fathers at night prep their next day's uniforms and shine their boots prior to their early 3:00 a.m. start times.

Don Ewald (1909–1973) was the youngest of the four Ewald brothers; he found his niche in the dairy's personnel recruitment and purchasing. Don was the quietest of the four brothers and became known for the detailed records he kept of the early growth years. The four brothers all lived within two blocks north of the dairy, and all but Ray moved in the early 1950s to homes on Golden Valley property formerly owned by Dewey. (Courtesy Norton & Peel.)

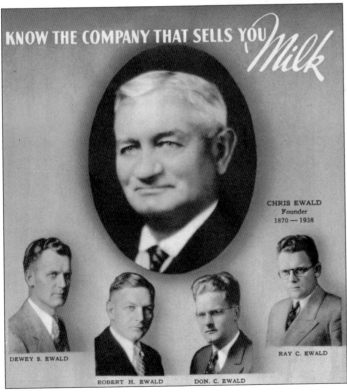

"Know the company that sells you milk." In 1938, the same year Chris passed away, this image from a large foldout brochure emphasized the importance of knowing the folks behind the bottle of milk. Ray, Dewey, Don, and Bob are shown here with a prominent picture of their late father, Chris. He was known throughout the city of Golden Valley as "Dad Ewald." Ewald Bros. would always include his image in their advertising so as to never forget their roots.

73

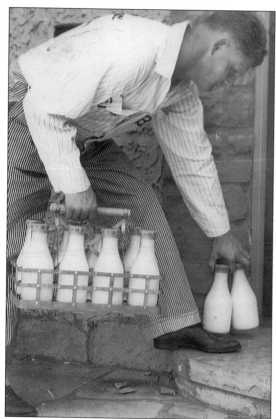

Ralph Ewald is shown on his route in the early 1930s. The round bottles were soon replaced by square bottles. Many of the Ewald milkmen worked their entire careers for the company, having only filled out one application and had one interview, which usually involved a brief arithmetic quiz and customer service–related questions. Ralph represents a generation of milkmen who started out with horses and wagons and transitioned to delivery trucks. He eventually ended up working inside the creamery supervising the drivers. (Courtesy Norton & Peel.)

April 12, 1946, was a big night for "Mom" Ewald when Ewald Bros. Dairy celebrated its 60th anniversary at the Nicollet Hotel in Minneapolis. Gertine Ewald, age 71, wife of the company founder, headed the list of honored guests. Her four sons, from left to right, Dewey, Ray, Bob, and Don, are pictured with her. More than 450 people, including 250 employees and civic leaders, attended this event.

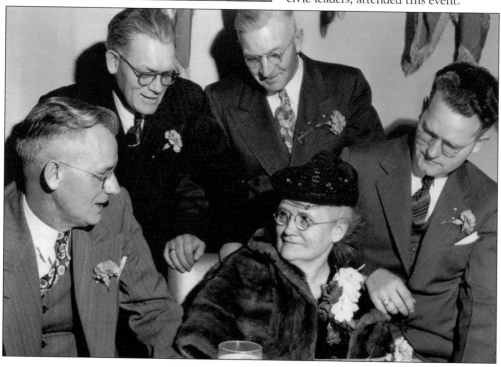

Every Sunday, the Ewalds featured a different driver in the Sunday edition of the *Minneapolis Star Tribune*. Frequently on Tuesdays, full-page ads were run to promote different aspects of the dairy. Here, the new half-gallon milk bottle is introduced.

Ethel Smith (1902–1985) and Raymond Clarence Ewald were married in 1922. Ethel was one of four children born to C.C. and Nellie M. Smith of North Minneapolis. She graduated from North Minneapolis High School. Following their marriage, Ethel was active in community organizations, particularly the Willard (elementary) School and North Minneapolis High School's PTA and the Salvation Army's Women's Auxiliary. She and Ray were parents of six children, two of whom died in early infancy. Along with her Ewald sisters-in-law, Ethel was involved as support staff at the dairy in the 1920s as the company began its rapid growth.

Ralph Ewald (1905–1963) was a cousin of the Ewald brothers; Ralph's father, Nels, was Chris Ewald's brother. Ralph and brother Jack Ewald spent their working lives at the dairy. Ralph began as a milkman and moved to the production floor of the dairy. Prior to his death in the 1960s, he was the milkmen's supervisor. His brother Jack, who also had extensive route experience, became the office manager in charge of the financial records and functions of the company. (Courtesy Norton & Peel.)

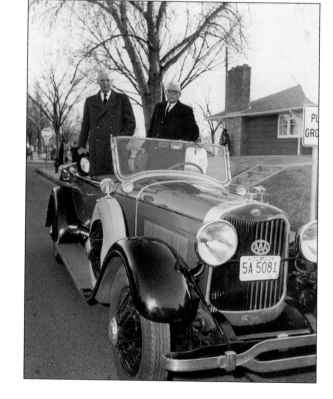

For the 75th anniversary in April 1961, the Ewald Bros. Dairy held a parade to commemorate the 50th anniversary of moving their herds of cattle across the city. The Ewalds used 50 trucks to mark the occasion, with Ray and Dewey leading the parade. (Courtesy Bruce Sifford Studio.)

Raymond Clarence Ewald (1900–1969) was the "Mr. Outside" of the dairy's two senior partners. Ray was responsible for the advertising, promoting, and community and public relations; he was the face of Ewald Bros. Dairy. Ray believed that "nothing ever happens until someone sells something" and that more things get sold when businesspeople become involved in community development and growth. (Courtesy Zinmaster Studio.)

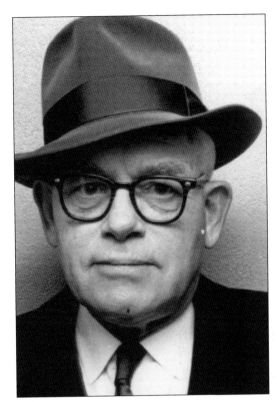

Pictured on November 4, 1954, is future US Supreme Court clerk Frank Larkin. At the time, he was a 38-year-old Hopkins, Minnesota, farmer-milkman who could not campaign more than 100 miles away from the Twin Cities because he had to get up at 4:30 a.m. every morning to deliver milk for the Ewalds.

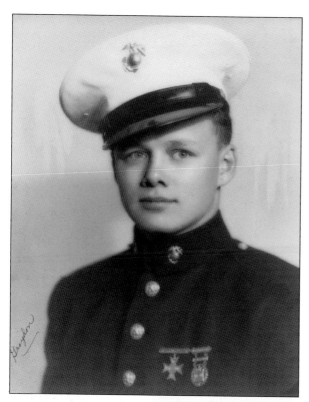

Graydon Ray Ewald (1924–2008) was the first child born to Ethel and Ray Ewald. He attended Minneapolis public schools and graduated from Breck School in St. Paul. Graydon was full of life. He was always as quick with a smile as he was on his feet; he was named All-Conference Quarterback his senior year at Breck. He attended the University of Minnesota and enlisted in the Marines. He and his wife, Diane Martin, of St. Paul, were the parents of six children. They left Minneapolis for health reasons in the 1980s; prior to that, Graydon had spent his whole working life at the dairy. Graydon's major responsibilities were the relationships and negotiations with the Milk Drivers Union as well as overall management of the dairy's 180 retail and 15 wholesale routes. Upon incorporation, Graydon was named vice president of the dairy.

Ethel and Ray Ewald's youngest son, Doug, worked odd jobs at the dairy while growing up, and from 1962 to 1968, he was secretary-treasurer. Doug graduated from Minneapolis North High and the University of Minnesota, where he received his bachelor's and master's degrees in health care administration. He left the dairy to work for the North Central Milk and Ice Cream Association. He was the first president of the Twin West Chamber of Commerce and served four terms in the Minnesota House of Representatives.

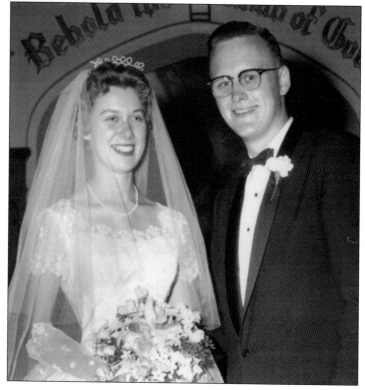

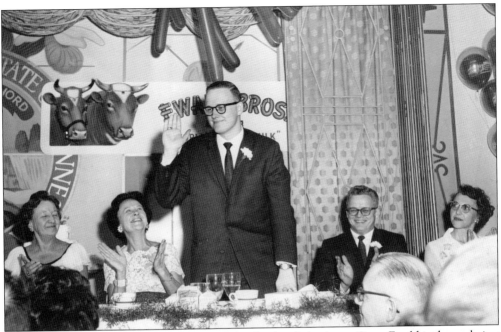

Upon returning from Rhode Island to work for the family business, Doug Ewald is shown being introduced at one of the many Ewald anniversary parties at the Radisson in Minneapolis in 1962. (Courtesy Norton & Peel.)

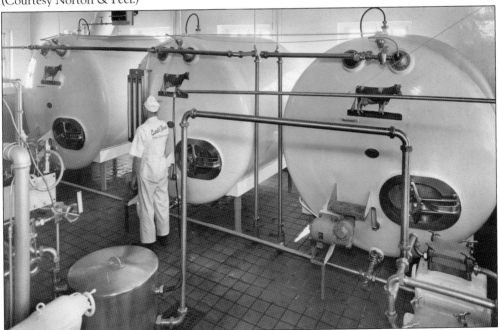

Careful monitoring of the equipment that produced the dairy products required extensive training and dedication. Most of the "inside plant men" had worked their way off the milk routes and had an increased level of appreciation for how the milk was produced. Only a few men were needed to work inside the milk production areas to control the quality the Ewalds insisted upon. (Courtesy Norton & Peel.)

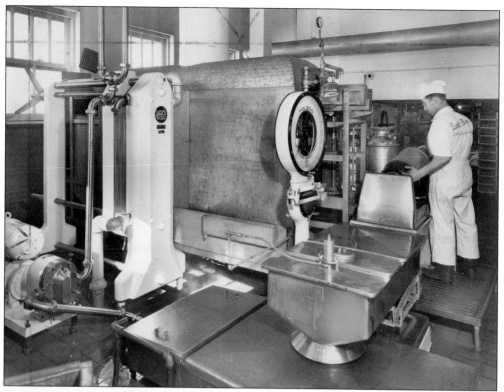

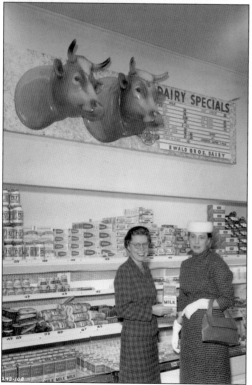

Once the Ewalds stopped producing their own milk, they relied on a steady supply of raw milk from 60 neighboring farms. These farms were all under the close supervision of certified Golden Guernsey inspectors and the Ewalds themselves. The raw milk would arrive in eight-gallon cans, weighing close to 70 pounds, and one by one, they were manually dumped into receiving tanks for clarification prior to being pumped upstairs for butterfat testing and production. The steel containers would flow through an assembly line of conveyers for sterilization before being returned to the farmer. (Courtesy Norton & Peel.)

Inside the Jensen's Super Valu on October 4, 1957, Lorraine Ewald, wife of Dewey, and Dorothy Jensen admire the dairy case full of Ewald Bros. Dairy products. The custom sign on the wall, featuring the well-recognized Golden Guernsey cows, drew attention, especially of children, to the products. Prior to meeting and marrying Dewey, Lorraine was originally an employee of Ewald Bros. Dairy. (Courtesy Doug Jacobsen.)

Smiling Ewald milkman Joe St. Dennis navigates a much appreciated freshly shoveled sidewalk in February 1948. The wide side doors on the Divco delivery vehicles, along with the ability to stand while driving, enabled the milkmen to exit and enter quickly to make their 100–150 stops per day. It was well known that one could always recognize a milkman's home by the shoveled sidewalk, which was also appreciated by the mail carriers. (Courtesy St. Dennis family).

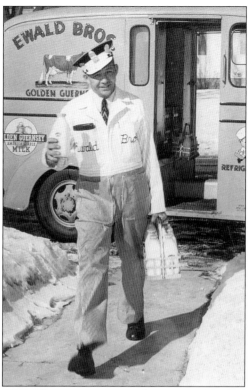

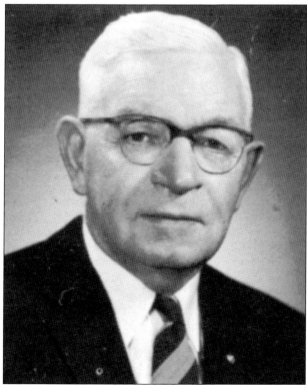

Robert "Bob" Ewald (1895–1977) was the oldest of the four Ewald brothers. Throughout his life, he was involved in wholesale customer development and support, among other duties in the dairy. Bob was a customer and employee favorite who was always quick with a story and totally committed to the growth of the company. (Courtesy Norton & Peel.)

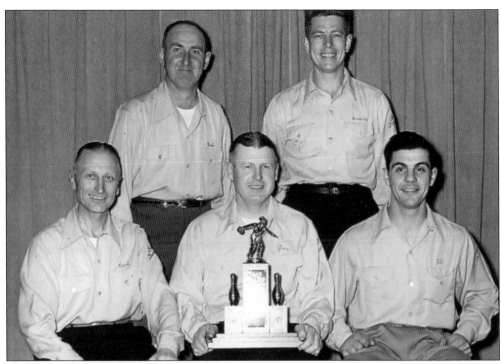

The milkmen of Ewald Bros. Dairy were a competitive group, both on the route and in the field. Most milkmen were members of the Teamsters' union, which organized sporting events pitting the many dairies against each other. Ewald Bros. sponsored football, hockey, diamond ball, and many bowling leagues for its employees. Shown here with a first-place bowling trophy are, from left to right, (first row) Carl Anderson, Jim Olsen, and Al Step; (second row) Harold Swanson and Duanne Jorenson.

The Ewald Christmas parties were well remembered by families. This tradition was started by Gertine Ewald in the original farmhouse and later moved to banquet facilities to accommodate the growing number of employees and their families. Santa Claus attended and had personalized gifts for each of the employees' children. Often, the entertainment was provided by the employees. Sterling McCarthy, a multi-talented Ewald employee and musician, was a favorite performer at Christmastime. (Courtesy Corrine McCarthy.)

Ronnie Parsons is one of the many Ewald employees who left their jobs to serve the country during wartime. Ronnie left to join the US Navy with the security of knowing his job would be there when he returned. The company provided financial compensation and dairy products to the families of enlisted employees.

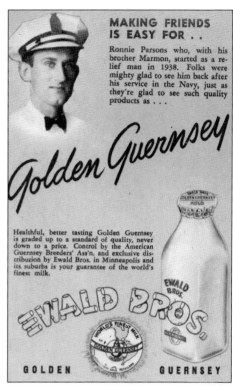

MAKING FRIENDS IS EASY FOR . .

Ronnie Parsons who, with his brother Marmon, started as a relief man in 1938. Folks were mighty glad to see him back after his service in the Navy, just as they're glad to see such quality products as . . .

Golden Guernsey

Healthful, better tasting Golden Guernsey is graded up to a standard of quality, never down to a price. Control by the American Guernsey Breeders' Ass'n. and exclusive distribution by Ewald Bros. in Minneapolis and its suburbs is your guarantee of the world's finest milk.

EWALD BROS.

GOLDEN GUERNSEY

This photograph is from January 1959, but regardless of the decade, the technique of loading bottles into crates never changed. The Ewalds insisted that the process be done by hand as it served as the final inspection of the product. After the crates were loaded, they were taken to the cooler for the next morning's delivery. At the dairy's peak, up to 50,000 gallons of milk were processed per day. (Courtesy Norton & Peel.)

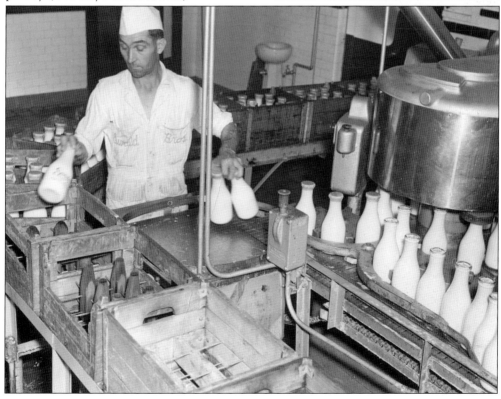

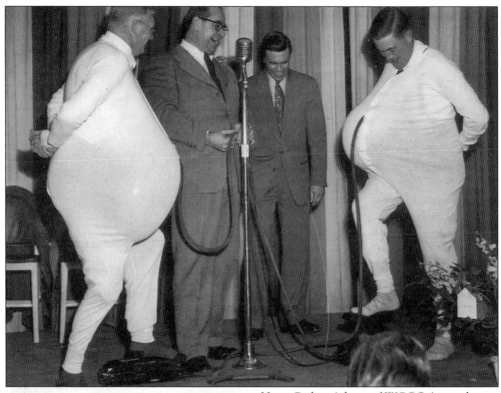

Here, Cedric Adams of WCCO (second from left) encourages Ewald employees who playfully volunteered to be his subjects at an Ewald anniversary party in April 1940. Throughout his broadcasting career, Adams was respected and loved by the Ewalds.

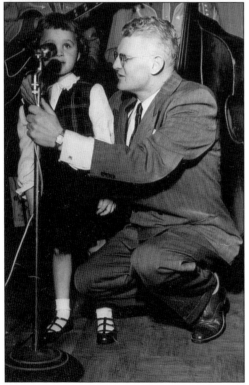

In 1946, Ralph Ewald helps a young girl reach the microphone at one of the annual Ewald Christmas parties. Including the employees' families at banquets, summer picnics, Christmas parties, and other significant occasions was something Ewald Bros. Dairy took great pride in.

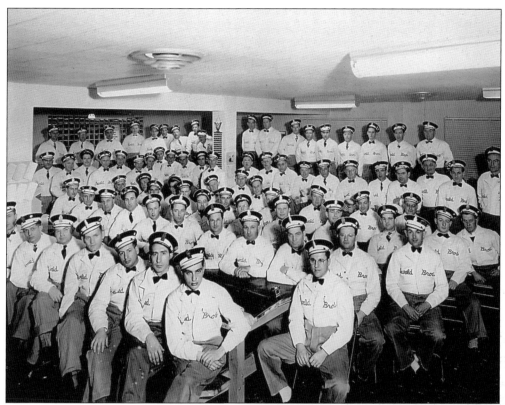

Inside the drivers' room, nearly 150 milkmen reconciled their daily books, took breaks, and posed for numerous pictures that were sometimes featured in the company's weekly advertising. Many generations of families were Ewald milkmen. Many of these men proudly worked their entire careers with Ewald Bros. Dairy. (Courtesy Norton & Peel.)

This 1965 photograph shows milkman Jerry Leiner arriving at the Golden Valley home of Douglas Ewald. It was common for the Ewald milkmen to enter their customers' unlocked homes, sometimes as early as 3:30 a.m., to fill the refrigerators with the previous day's order. In the milkman's carrying basket are containers of the nationally recognized juice Beep and the original Sunkist Lemonade, formulated exclusively by national brand Sunkist using Ethel Ewald's personal recipe that involved adding fresh orange juice to the popular drink.

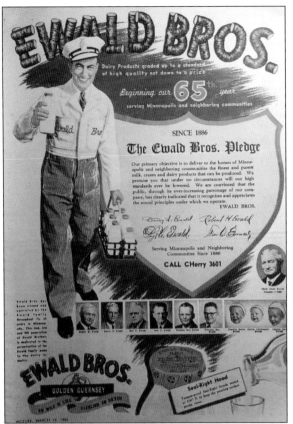

In 1951, the Ewald family celebrated their 65th year in business. The 65th anniversary marked a significant achievement for the dairy, as many of the other dairies that previously existed had failed for one reason or another. In this April 22, 1951, ad featured in the *Minneapolis Star Tribune*, the Ewald brothers introduce Ray's sons Graydon and Douglas Ewald and Graydon's three sons. Bob Fisher is shown holding the milk and was a regular and well-known face in the company's advertising.

On November 15, 1959, Ray and Dewey Ewald stand outside their creamery awaiting drivers returning from their daily deliveries. The dairy was nearing its peak capacity with nearly 250 full-time employees. In a few short years, the dairy's strategy would shift from home and commercial deliveries to supermarkets.

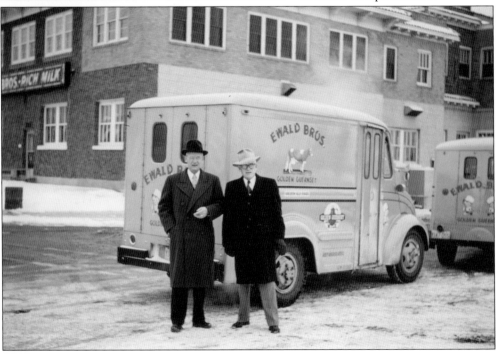

On April 3, 1962, Dewey (seated, far right) and Ray Ewald review the most recent union contract offered to their employees. Ewald Bros. Dairy was the only Minneapolis dairy never to have a strike or a lockout, always choosing to negotiate with employees to keep them happy and working. During a milk drivers' strike in the 1930s, Ewald Bros. was selected by the state to be exempt from the strike in order to provide dairy products, specifically milk, to hospitals and schools, as it was deemed necessary in order to meet state guidelines on nutrition. (Courtesy Norton & Peel.)

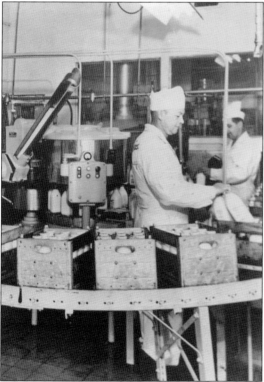

The creamery was producing milk seven days a week to keep up with the shipments of raw milk from their nearly 60 producers. Bottling or packaging 50,000 gallons of milk per day along with producing butter, sour cream, buttermilk, juices, and other dairy products meant a very fast-paced environment. This photograph shows a conveyer with men hand-loading bottles into crates. Hand-packing meant quality control for the Ewalds, and though it required more labor, it ensured that the bottles were individually inspected. (Courtesy Norton & Peel.)

On May 15, 1936, Ralph Ewald displays the new square space-saving bottle. Ewald Bros. Dairy switched to square containers to provide the homeowners more room in their refrigerators. Eventually, the company replaced glass with cardboard and then plastic. The Ewalds insisted on maintaining the glass bottles for as long as possible due to the unique tint of their milk that they felt was important for the consumer to see. (Courtesy Norton & Peel.)

Golden Guernsey was a national organization of highly committed dairy industry professionals that continuously pursued the highest standards of quality and sanitation. Insisting their registered farmers and dairies met the highest standards of production, they often offered promotional material that had been stamped with the local dairy's name and distributed to their customers. These often included coloring books and other engaging activities for children.

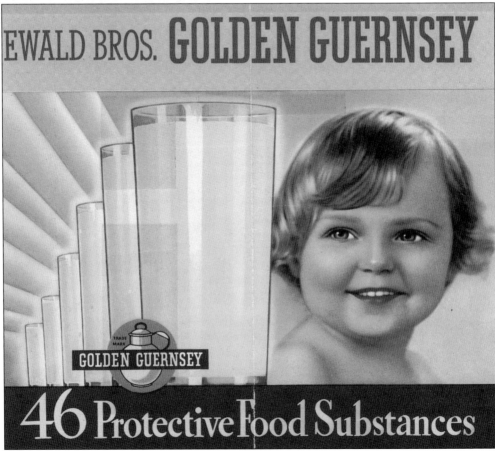

All of the Ewald milkmen were unique, and each brought something special to his route. Carrol Cast was a milkman's milkman. He was deliberate and thoughtful and cared for his customers. Customer care was his specialty; he knew his customers' birthdays as well as their likes and dislikes. His route book was always organized, with all entries neatly completed. Cast was never the first man to finish for the day and in fact was often the last, but when his day was over, there was no work left to do.

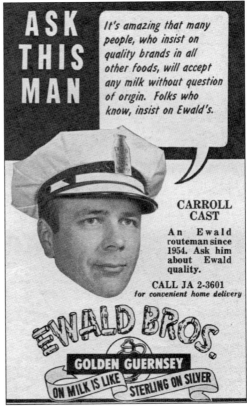

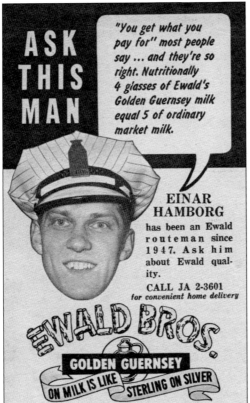

The Ewalds were extremely proud of their many employees and took every opportunity in the weekly newspapers to recognize them and their achievements. Numbering close to 150 milkmen, large group photographs were used to fill in the gaps of the individual pictures that were frequently used in the *Minneapolis Sunday Tribune Picture Magazine*. Einar Hamborg was responsible for one of the company's many commercial routes primarily in the Downtown Minneapolis area. Driving a large truck, considered a "moving advertisement" by Ray Ewald, was one of Einar's passions, and his professionalism on the roads and with his customers made him a respected Ewald employee.

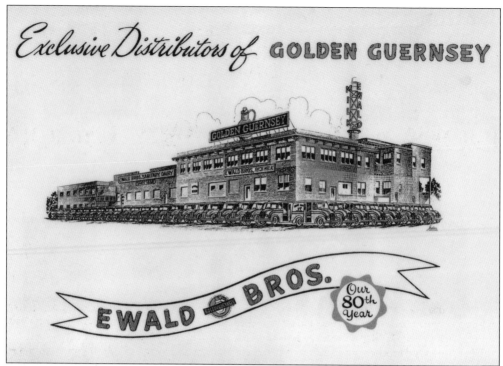

Exclusive Distributors of GOLDEN GUERNSEY

EWALD ● BROS.

Our 80th Year

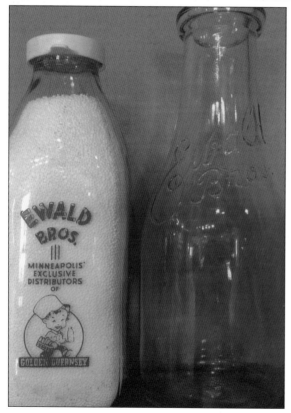

The year 1966 marked Ewald Bros. Dairy's 80th year in the dairy business. This special anniversary was marked with handouts commemorating the event. Without the extraordinary dedication of the "people behind the bottle of milk," Ewald Bros. Dairy's growth would have ended much sooner.

The Ewalds made the decision to convert from hand-dipping milk out of containers to delivering milk in bottles about the same time most other Minneapolis dairies did, in the late 1920s. Round bottles came first, followed by square bottles. The Ewalds ordered their bottles in lots of 20,000 and paid 7¢ to 11¢ for them depending on the size. The lifespan of a bottle averaged eight round-trips before being discarded for "crate wear," which was caused by the constant rubbing on the wood and steel crates. Once the conversion to cartons was complete, Ewald Bros. Dairy, like other dairies, disposed of hundreds of thousands of bottles in dumps and landfills.

Five

Does a Community Good

Chris Ewald set a standard of community service for all the employees of the Ewald Bros. Dairy and encouraged them to volunteer within the community that supported the dairy. Chris was one of Golden Valley's first constables ensuring law and order within the city limits.

All of the Ewald brothers and Ray's two sons were Masons and members of the Plymouth lodge in North Minneapolis, the Scottish Rite, and Zuhrah Shrine. Ray reached a milestone with the Masons when he received the ultimate honor, the 33rd degree. When the Golden Valley Golf Club was put up for sale, it was Ray who engineered its purchase by the Shriners, who renovated the club and used it as a venue to support local high school academic achievement programs, among others community-focused events.

Ray Ewald, known as "Mr. Outside" for his fond interest in community service, took pride in working with countless civic organizations to help ensure the success of the cities they conducted business in. Ray served on the Minneapolis City Planning Commission, participated with the On to Nicollet Committee bringing minor league baseball to Minneapolis, and was a charter member of the Minneapolis Aquatennial in 1939, a board member of Glenwood Hills hospital, and a member of the American legion, Minneapolis Chamber of Commerce, and the Minneapolis Optimist Club. His wife, Ethel, chaired the annual Salvation Army Woman's Auxiliary drive.

Ralph Ewald served as the annual chairperson for the Sister Kinney institute. During the polio epidemic, all Ewald milkmen raised money during their routes for polio research under the direction of Ralph.

Youth sports, regardless of the school or community, were often sponsored by the company along with recognition of academic excellence. Professional athletics were not ignored, as the company became active sponsors with the Minnesota Twins, Vikings, and the world-champion Minneapolis Lakers basketball team.

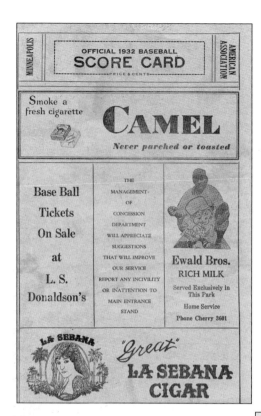

The Nicollet was a former baseball park in Minneapolis that was home to the Minneapolis Millers of the Western League, and later American Association. The park was originally known as Wright Field, named for one of baseball's founding fathers, Harry Wright. The wooden stadium was replaced by concrete in 1912, with lights being installed in 1937. The ballpark was bounded by Nicollet Avenue on East Thirty-First Street South. The Ewald brothers provided strong support for this ballpark, helping to raise funds for improvements. The company was also represented in the stadium beginning in the early 1900s and through the park's history. (Courtesy Steve and Cher Hamborg.)

Chris Ewald was not only a dairyman but also the Golden Valley City's constable. He is pictured posing on a donkey in a 1932 publicity shoot for the city. Chris led a team of volunteers whenever there was a disturbance within the city limits that the police department would not ordinarily respond to. Horse thieves, noise disturbances, and curfews and other infractions were some of the things Chris handled. He served as constable for three terms, from 1926 to 1932.

The Northside Minneapolis picnic was looked forward to by many. Shown in this image is Ray Ewald, chairman of the picnic committee. Most of the Ewalds resided on the Northside.

Pictured on February 22, 1951, eight-year-old ski-jumper Mark Schurke is flanked by Ray Ewald, left, and Mayor Eric Hoyer. Schurke made the first jump in the Central US Junior Ski-Jumping Meet at Theodore Wirth Park. Mayor Hoyer is presenting him with a Centennial Sports Certificate, which went to all 200 jumpers.

Members of the Minneapolis City Planning Commission (1937–1939) are, from left to right, Miss Turney, Herman Olson, O.B. Erickson, Mr. Stevens, Alderman Miller, Walter Johnson, Walter Quist, and Ray Ewald. The planning commission was one of the many civic responsibilities the Ewalds participated in. (Courtesy Norton & Peel.)

City of Minneapolis
Planning Commission
1937 - 1939

Madagascar president Philbert Tsiranana and his wife visited Dewey Ewald in 1964 to get a better understanding of milk processing. The president was visiting Minneapolis as part of an agricultural agenda organized by the governor. While in Minneapolis, the president explored new farm and production practices. Ewald Bros. Dairy had been selected by the governor's committee along with several other Minneapolis dairies and facilities that were using state-of-the-art technology. (Courtesy Bruce Sifford Studio.)

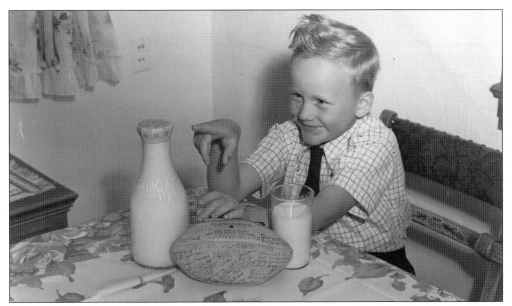

Posing for an advertisement, 10-year-old Douglas Ewald is shown with a fresh bottle of milk and a football signed by the national champion Minnesota Gophers. The Ewalds were longtime advocates for the University of Minnesota and used the relationship with great pride when they had the opportunity to promote their products. The Ewalds assisted with the building of Memorial Stadium on the University of Minnesota's campus. (Courtesy Norton & Peel.)

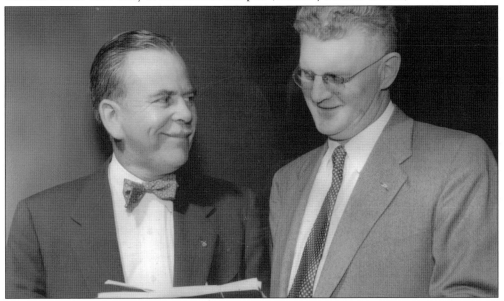

On June 5, 1953, Ralph Ewald, right, of Ewald Bros. Dairy and W. James Peterson of Hardware Mutual Life Insurance Co. joined efforts in the larger firm's division of volunteers as cochairmen for the 1953 polio fund appeal for the Elizabeth Kenny Foundation. The foundation was perhaps the most recognized organization in polio research. The Ewald milkmen helped raise funds and participated in the drive by passing out brochures to their customers. Roberta Clifford, a young girl from Hopkins, Minnesota, whose parents were Ewald customers, was one of Sister Kenny Institute's first patients to be studied.

On October 26, 1960, the Washington Senators moved from Washington, DC, where they had resided since 1912. Moved by owner and president Calvin Griffith to the Minneapolis–St. Paul area, the team was aptly renamed the Minnesota Twins, as it represented both sides of the river. The dairy immediately joined with the club, providing advertising support throughout the team's existence at the former Met Stadium, where the Twins played. The Ewalds had a long relationship with baseball in the cities, supporting all levels from Little League to Major League.

Beginning in 1941 and lasting through 1964, the Minneapolis Aqua Follies were held at Wirth Lake not far from where the Ewald boys once farmed. The twice-daily shows were attended by as many as 50,000 spectators who would come to witness diving events and other water sports in an Olympic-size swimming pool that was built to host the event. The dairy became a charter sponsor of the event in 1941, providing advertising, discount tickets, and dairy products for the concessions.

The annual Minneapolis Aquatennial was Minneapolis's biggest summer celebration, with 12 days of events. The floats in the parades were generally sponsored by large companies. Minneapolis retailer Dayton's set the standard for high-quality floats, with Ewald Bros. Dairy not far behind. The dairy's sponsorship of the Aquatennial Junior Royalty Competition was an annual tradition. Ray Ewald served on the Minneapolis Aquatennial Committee for years and once served as vice commodore.

Ray Ewald was recognized as 33rd-degree Mason. He and his brothers contributed greatly to the Scottish Rite and Freemasonry. (Courtesy Zinmaster Studio.)

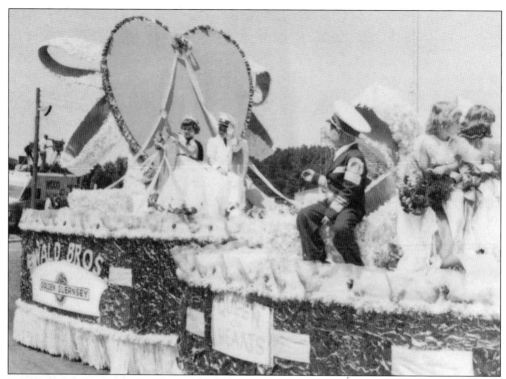

LET'S TAKE A TRIP WITH
Johnny Kundla
COACH OF THE MINNEAPOLIS LAKERS
THRU EWALD BROS. DAIRY

The Minneapolis Aquatennial is an annual outdoor event that began in 1940 and is held in the month of July. The event celebrates the city's lakes, rivers, streams, and other bodies of water.

In 1947, the disbanded Detroit Gems were purchased and moved to Minneapolis, where they were renamed the Minneapolis Lakers in recognition of the state's 10,000 lakes. The Lakers would immediately prove themselves successful, winning several national championships while in the city. Ewald Bros. Dairy partnered with Lakers coach John Kundla upon his arrival and quickly provided him and his family a tour of the Ewald creamery. The Kundla family became Ewald customers after visiting the dairy and appeared in numerous advertisements during the team's years in Minneapolis.

On September 22, 1948, Gov. Luther Youngdahl; his wife, Irene; and Ray and Ethel Ewald prepare to board a train bound for Michigan to witness the Michigan Wolverines football team play the Minnesota Gophers. The Ewalds were particularly fond of the Gophers. In 1962, when the Golden Gophers won their first and only Rose Bowl, Ewald Bros. Dairy produced special milk cartons celebrating the feat.

While sponsoring youth clubs, sports, and other organizations, Ewald Bros. Dairy always provided the necessary support for uniforms, as well as advertising. This image shows the dairy's St. Louis Park Little League Baseball Association–sponsored team. Skippy Field in St. Louis Park was named for its proximity to the Skippy peanut butter factory, which was located across Highway 7. Skippy Field was the home turf for the Ewald Bros. Dairy team. (Courtesy Banbury Studio.)

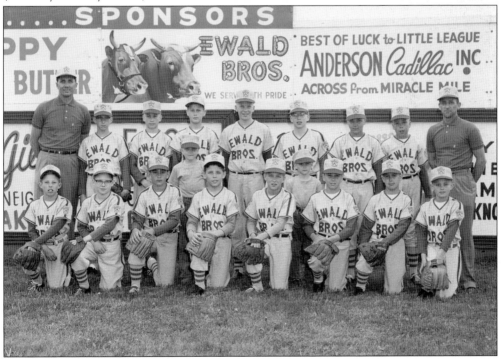

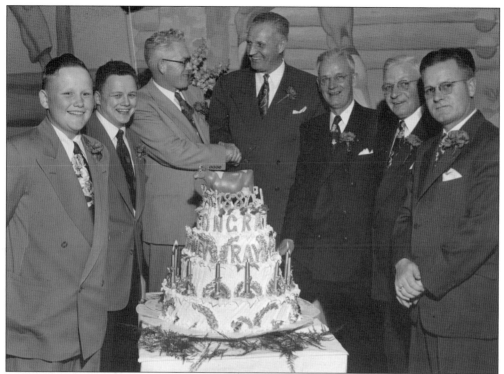

On March 3, 1951, at the Ewalds' 65th anniversary celebration, Governor Youngdahl (center) shakes hands with Ray Ewald at the Nicollet Hotel in Minneapolis. Standing next to the governor are, from left to right, Dewey, Robert, and Donald Ewald. Some 600 people attended the event, including current and former employees and spouses. Minnesota's governors were always the main speakers at these events, followed by mayors, clergy, and other dignitaries. (Courtesy Norton & Peel.)

Shown here on June 2, 1951, are, from left to right, Paul Johnson, J.C. St. Marie, and Ray and Ethel Ewald celebrating an anniversary for the Zuhrah Temple of the Shriners.

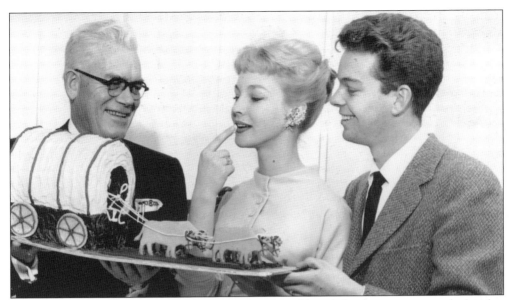

On February 18, 1956, Minneapolis became 100 years old, and the occasion was marked with a special cake. Ray Ewald (left), head of the Minneapolis Centennial Committee, is seen accepting the covered wagon–shaped birthday cake from Russ Tamblyn and his wife. Tamblyn was in the cast of the movie *The Last Hunt* and made the presentation. This unique cake was made in the General Mills experimental kitchens in Golden Valley.

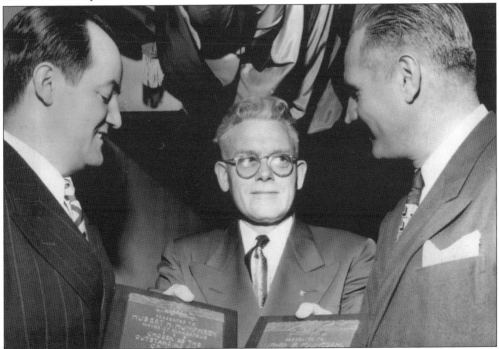

On March 2, 1948, Ray turned the tables and presented honored guests Mayor Hubert Humphrey and Governor Youngdahl with plaques for being Minneapolis leading citizens. The annual event was held at the Minneapolis Radisson and was attended by 500 of the Ewalds' friends and business acquaintances.

Great tasting milk at school could
potentially lead to additional
home customers, and so the
Ewald brothers supported the
schools not only by supplying
milk, but also by participating
in numerous events.

Celebrating the Golden Valley
Country Club's second year
under the ownership of the
Shriners, Ray and Ethel Ewald
cut into a cake. The club went
on to host many community
and school events with the
guidance of the Shriners.

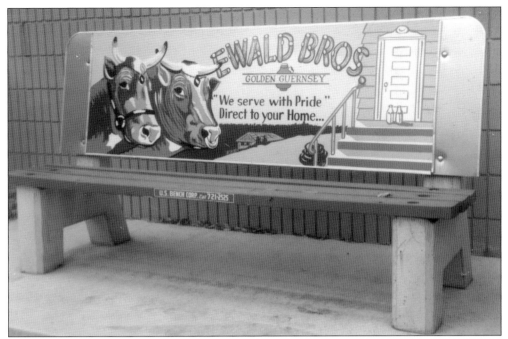

The US Bench Corporation of Minneapolis handled all of Ewald Bros. Dairy's bus bench advertising. Each sign was hand painted from an artist's proof and individually manufactured. The heavy enamel paint made for a durable piece that would withstand the Minnesota weather. The concrete-and-wood benches were considered to be among the most enduring components of the Twin Cities streetscapes in the 1950s and 1960s, with close to 2,500 within the city limits.

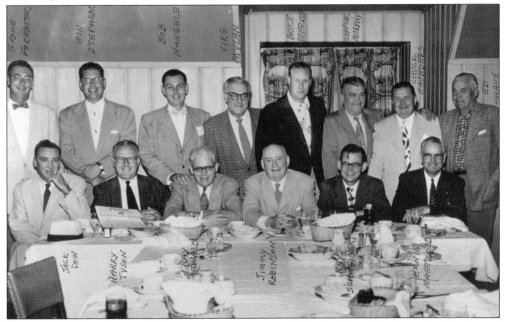

Raising funds for a hunting habitat was a true passion of Ray Ewald and his boys. Ray is pictured at this annual gathering of business leaders seated third from left, next to hunting authority Jimmy Robinson. (Courtesy the Naegele family.)

EWALD BROS.

MILK

WANTED

Occasionally, Ewald customers would run short of milk before their next scheduled delivery. When this happened, the milkmen provided their customers with placards that could be placed in the window, door, or other visible spot signaling the milkmen to stop.

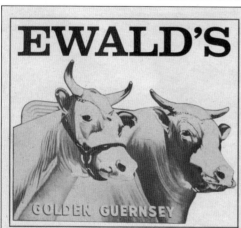

EWALD'S

GOLDEN GUERNSEY

Howard Wong's

CHINESE FOODS

2701 W. 78th ST.
FREEWAY 494 AT PENN AVE. EXIT

The American Football League awarded Minnesota a franchise in 1960 that began competing in 1961. The team was officially named the Vikings on September 27, 1960, partly to reflect Minnesota's place in Scandinavian American culture. The Vikings were instantly popular with the fans, and recognizing this opportunity, Ewald Bros. Dairy signed an early agreement as a sponsor of the team.

Ray Ewald represented the Ewald brothers on the On to Nicollet Committee, an organization that pulled together individuals and business partners who served as boosters for the minor league baseball team. The Minneapolis Millers and Nicollet ballpark played an important role in amateur Minneapolis sports for decades, and the boosters helped support the organization by selling tickets and promoting the team's events. Numerous community events were held at the Nicollet ballpark, forging a positive relationship between amateur teams and the community.

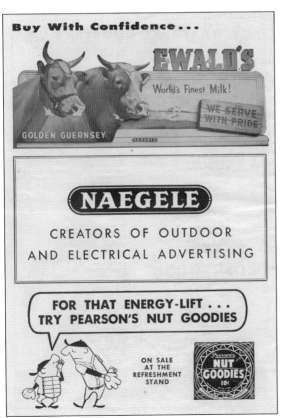

Three Minnesota companies advertise together in a 1951 Minneapolis Millers' scorebook. Naegele, the producer of Ewald Bros. Dairy's outdoor advertising, and St. Paul–based candy maker Pearson's supported the ballpark for decades. The Millers generated many high-caliber athletes, including Ted Williams, Willie Mays, and Carl Yastrzemski. Broadcaster Halsey Hall was the Millers' play-by-play man from 1933 until the club folded in 1960, when the Washington Senators relocated to become the Minnesota Twins.

Raymond Ewald shakes hands with the past Golden Valley Country Cub president in recognition of the club's mortgage burning. Ewald was the first president of the country club and served on its board for decades. It is a well-known fact that when the Ewalds converted from glass to cartons, Ray had the glass bottles dumped on the grounds of the country club and covered with dirt and grass to become part of the rolling hills of the landscape. The Golden Valley Country Club became a primary venue for many of the fundraising efforts that the Ewalds supported, primarily for the Shriners and Salvation Army.

Ray and Ethel Ewald are shown in December 1961 with a handful of Rose Bowl tickets each. The Ewald family has been longtime supporters of University of Minnesota athletics and used this opportunity to show their admiration on the side of a custom milk carton. The Gophers won the January 1, 1962, Rose Bowl, defeating the University of California, Los Angeles, 21-3.

Six

END OF AN ERA

Ewald Bros. Dairy started with door-to-door milk delivery from a hand cart and proceeded to horse-drawn wagons, then to refrigerated home-delivery trucks. The company reached its pinnacle when it became the largest home-delivery dairy in Minneapolis, delivering milk to one of every three homes that received home-delivery milk in the mid-1960s.

There were several factors that affected home delivery in the Twin Cities dairy industry and specifically the Ewald Bros. Dairy. The nearly 100-year-old dairy would eventually fail for several reasons.

Ewald Bros. Dairy was known for specializing in Golden Guernsey milk, a brand exclusive to the dairy and characterized by the extra richness of milk from Guernsey cattle. However, dietary research in the late 1950s began to suggest that there was a relationship between rich dairy products and coronary heart disease. While Guernsey fat-free skim milk was a superior product, Ewald Bros.'s radio, television, and print advertising did not stress that fact.

The Ewalds had always stressed the importance of their milk being available in sparkling, glass bottles and hung onto that concept while other dairies quickly converted to cartons and then plastic. While there were advantages with glass, the disadvantages began to overtake them. The weight of the bottles and sanitary requirements cost Ewald Bros. a fortune.

With the rise of modern-day supermarkets in retail food sales, consumers quickly became familiar with, and accepting of, the newer packaging options, particularly with the lower prices available in stores. Ewald Bros. was late into the marketing of nonglass containers, and as supermarkets continued to increase their share in the dairy business, retail home delivery paid the price.

There were socioeconomic forces at work, too. As more women entered the workforce, home delivery became less of a convenience, especially with the ease of purchasing often less costly dairy products at stores.

Finally, the decision made by Dewey Ewald in 1969 to sever long-standing advertising relationships with Golden Guernsey, Naegele Outdoor Advertising, and WCCO radio sealed the fate of the once prominent dairy.

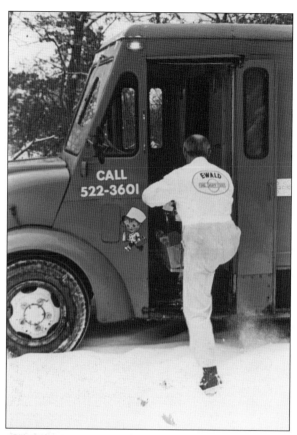

During the 1970s, the routine remained the same for the Ewald Bros. drivers. Although they had significantly fewer routes, each milkman would still make up to 100 stops per day. The weather did not seem to matter much to the men as they generally did not wear overcoats, perhaps only rolling up their sleeves in the summer.

Regardless of the decade, the milkman's day never ended until the empty steel crates were unloaded at the dairy. Sometimes an extra trip was needed, especially during the holidays, to unload and reload to keep up with the increased demand. The conveyers outside the building enabled several drivers to unload at once.

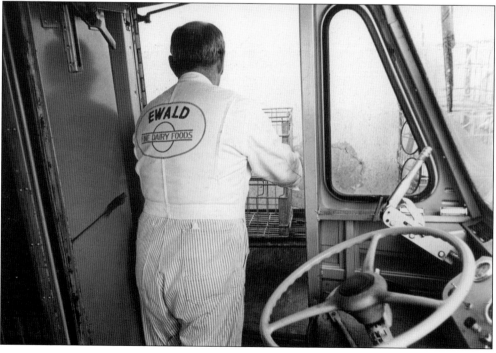

Taking inventory of the remaining load prior to unloading was an essential function of all milkmen. In some cases, inventory came back because it was not needed, and sometimes it was damaged in transit.

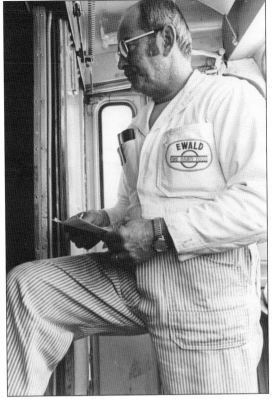

Sunny Jim is one of the few reminders of the paint schemes of the original Ewalds Bros. trucks. Still recognized by kids and remembered by adults, this friendly character was left on the trucks despite all the other changes.

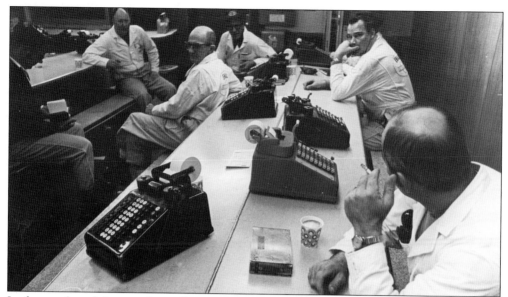

In the comfort of their trucks, milkmen often caught up on their paperwork between deliveries or after receiving an order change from a customer. Upon returning to the dairy, the milkmen would check in at the driver's window on the second floor and turn in their receipts for the day, as well as the next day's order to be staged. Impeccable record keeping was required as Ewald Bros. Dairy functioned without computers until the late 1970s. All of the milkmen's orders had to be combined for production order purposes so that the creamery did not run out of product. In addition to the orders coming in from the drivers, Ewald Bros. employed a large office staff to handle phone orders that also needed to be accounted for.

Loaded steel milk crates and constant shifting of inventory were just some of the many obstacles that a milkman would encounter. As the day's load lightened, this meant higher probability for shifting. Occasionally, the milkmen would encounter "cooked loads" when the refrigeration would go out on a hot day, causing the entire load to be returned to the creamery and discarded. Winter months provided their own challenges as well.

110

The familiar typeface of the Ewald name remained on the order slips; however, they were changed to read "Fine dairy foods." Dishwasher soap, laundry detergent, and cookies were added to the milkman's load in order to compete with the larger supermarkets rapidly expanding in the Twin Cities.

DATE _____ RT _____

NAME _____

ADDRESS _____

BALS DUE _____ .

PAYMENT _____ .

BALS DUE _____ .

THANK YOU

(YOUR MILKMAN)

NOTE: _____

✿✿✿✿✿✿✿✿✿✿✿

EWALD FINE DAIRY FOODS

EWALD DAIRY - Setting the standard of excellence for over three Generations.
CALL: 522-3601

"Direct to Your Home Since 1886" Date _____

EWALD DAIRY

HALF GAL	HOM. MILK
QUARTS	HOM. MILK
HALF GAL	2% MILK
HALF GAL	1% MILK
HALF GAL	SKIM
QUARTS	SKIM
PINTS	HALF & HALF
PINTS	WHIPPING CREAM
HALF PTS.	WHIPPING CREAM
HALF GAL	CHOCOLATE
QUARTS	CHOCOLATE
QUARTS	BUTTERMILK
8 OZ	SOUR CREAM
12 OZ	TOP-TATER
DOZEN	COOKIES
POUNDS	MARGARINE (BUTTER BLEND)
POUNDS	SOFT MARGARINE
12 OZ	COTTAGE CHEESE
24 OZ	COTTAGE CHEESE
DOZEN	GOLDEN GLO EGGS
7 OZ.	REDDI-WHIP
QUARTS	EWALD 100% - O.J.
HALF GAL	ORANGE JUICE DRINK
QUARTS	TROPICANA 100% ORANGE
9 OZ	CHEESE-Mont.J.Colby,Ched
HALF GAL	ORANGE DRINK
HALF GAL	CONCORD GRAPE
HALF GAL	FRUIT PUNCH
HALF GAL	LEMON LIME
10 POUND	DETERGENT
25 POUND	DETERGENT
QUARTS	EGGNOG (IN SEASON)
10 POUND	DISHWASHER SOAP
POUND	BUTTER (QUARTERS)

EWALD BROS., INC. MPLS., MINN. 469050

The Volvo tractors used to pull the semi-trailers for large institutional runs were universally preferred and known for their ability to navigate tight delivery docks; however, they were not always reliable due to the significant amount of stress put on the drivetrain. Ewald Bros. maintained six of these tractors to handle the volume of milk being delivered in the late 1970s and early 1980s.

Among the last trucks to deliver Ewald dairy products were these full-size stainless-steel trailers. The enormous weight loaded on these trailers placed a large strain on the smaller motors of Volvos, causing for frequent mechanical difficulties. These trailers were instantly recognizable driving down the freeways due to their bold coloring offset by the stainless steel. These trucks delivered to larger commercial accounts.

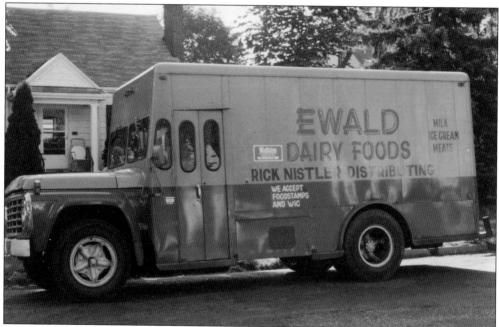

Ewald Bros. Dairy began subcontracting routes out to private owners in the mid-1970s in hopes of expanding their distribution area. These contractors would pick up dairy products at several dairies at wholesale pricing and be accountable for the distribution and billing. Privately owned home-delivery service is all that remains of this once heavily competitive industry.

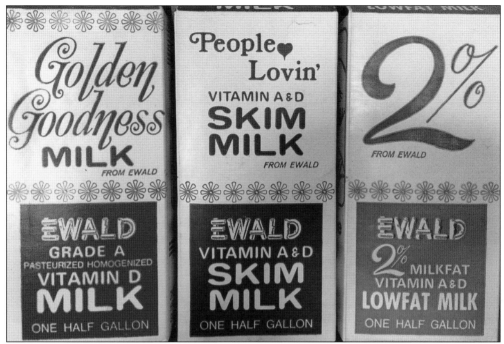

Produced at Marigold Foods, these Ewald-labeled cartons of milk clearly state "from Ewald." Whole, skim, two percent, and one percent milk have become the standard offerings accepted by consumers. Long gone are the higher-fat Golden Guernsey products that Ewald Bros. Dairy built its reputation on.

By 1979, Ewald Bros. Dairy continued to expand its product offerings to include yogurts, cheese, chip-dips, potato salads, and other favorites. These new offerings were intended for the supermarkets; however, they were delivered to the home consumer as well.

INVOICE NUMBER: 16128

EWALD BROS., INC.

KY-PD

2919 GOLDEN VALLEY ROAD • PHONE: (612) 522-3601

SOLD TO: Haug's Super Value ACCOUNT NO. 805 ROUTE NO. 100
ADDRESS 1750 Mw Blvd DATE 2-13-79 Ch. of DELIVERED BY

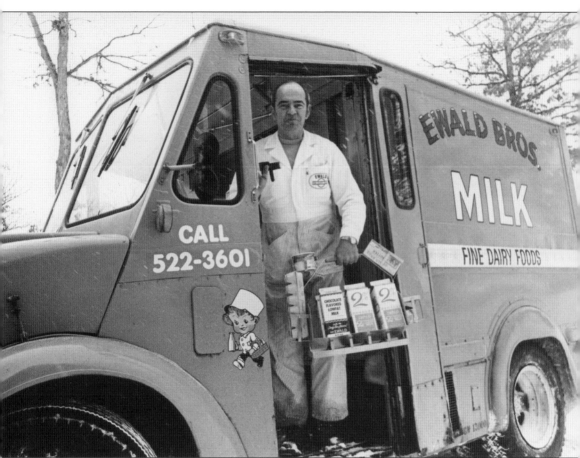

Here, a milkman with a fully loaded carrier is ready for a wintertime delivery. "MILK" has replaced the familiar friendly Guernsey cow that once occupied the sides of the truck. Once the decision was made to drop the Golden Guernsey label, Ewald Bros. Dairy began buying raw milk from the Twin Cities Milk Producers Association, eliminating the competitive advantage that they once had.

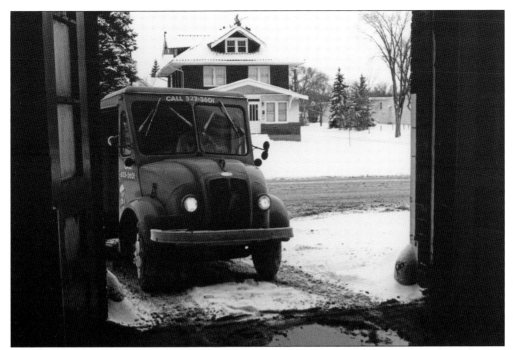

Here, an early 1950s Divco returns to the garage after a snowy delivery day. Once inside the creamery's garage, the truck would be washed, refueled, and eventually loaded with a pre-staged order. The trucks' refrigeration units were also plugged in.

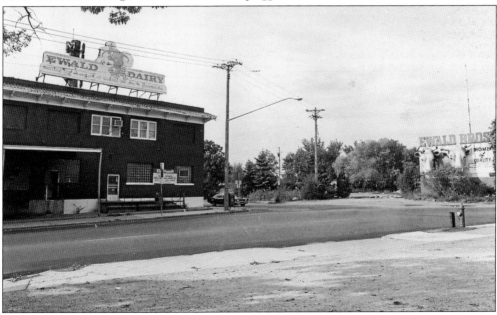

The now vacant Ewald Bros. Dairy is pictured for sale in 1981, its final year of operation. The building sat empty for two years before being demolished as it was no longer suitable for a dairy production facility or food processing. Due primarily to the custom setup of the building, including underground fuel tanks for the vehicles that would need to be dug up, it was difficult to locate another manufacturer to occupy the building.

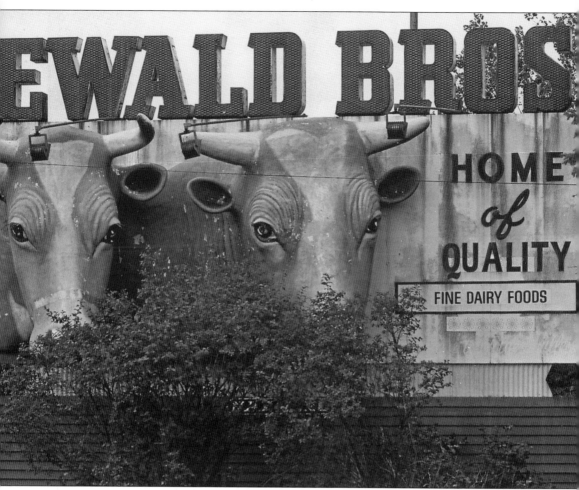

A rusted and worn sign, built by Bob Johnson and Naegele, still overlooks the now idle dairy. For over 40 years, this sign proudly stood watch over the bustling creamery and witnessed the dairy's transformations in reaction to the growing demand from consumers.

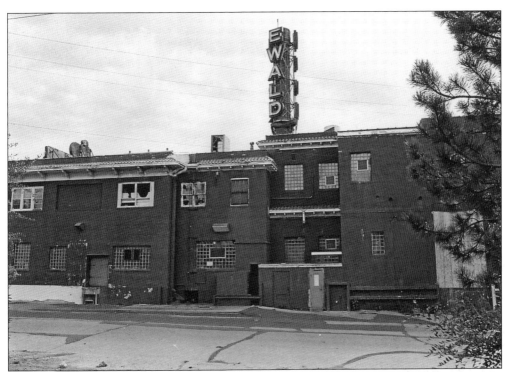

The side of the building shows where and how the expansions and modifications were made. The original cornerstone of the first creamery, built in 1920, still holds the building upright. The nearly two-block footprint of this building limited its horizontal expansion, forcing the Ewalds to build the second story that would ultimately prove to be less productive in a dairy operation, which are most efficient as a single story.

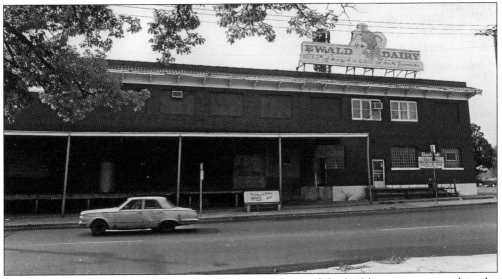

In the early 1970s, outside loading was added to the front of the building to accommodate the drivers who would now pull up and load their products rather than driving through the building. The interior space that once allowed a drive-through arrangement was consumed by new coolers to hold milk for the larger institutional accounts.

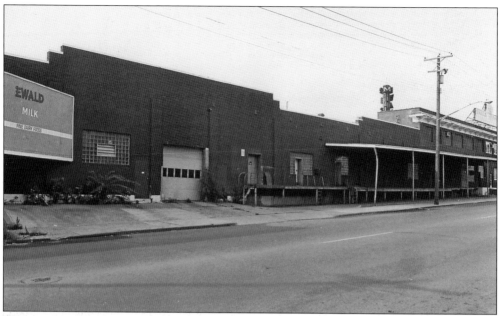

The garage entrance remained as an important part of the dairy operation as many of the Divco trucks needed more extensive repairs. The dairy still employed mechanics who would now be servicing the trucks after nearly every run.

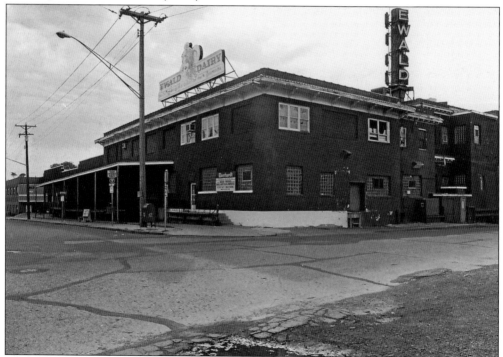

The length of the building and the front profile give the impression that this operation would be large enough to grow with the demand. Numerous changes were made to the building, like converting the once busy offices to storage and other needed space. Ray and Dewey's office windows are still visible here, while the others have been bricked over.

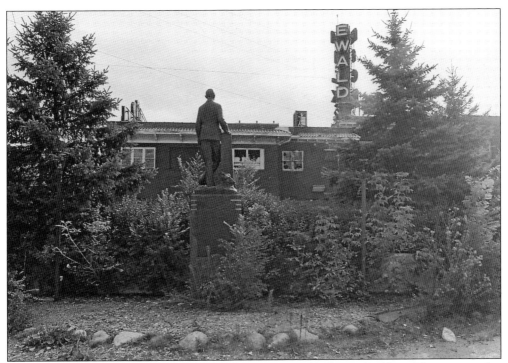

The statue of Chris Ewald is pictured standing watch over his former building. The area is today overgrown with trees and shrubs.

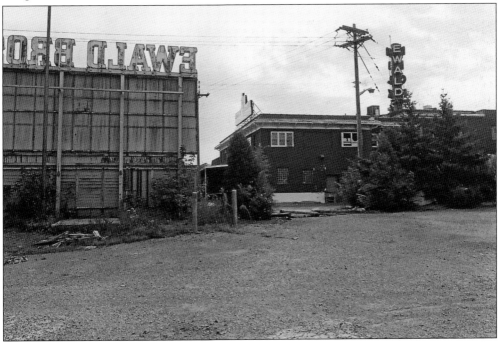

For decades, people would recognize Ewald Bros. Dairy's advertising from in front or behind due to the creativity of the Naegele designers who made sure to have them read from either direction using standout features like letters or silhouettes of the cows.

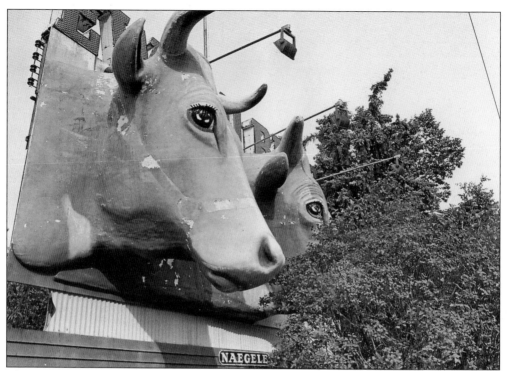

The wear on the cows now shows the same neglect as the dairy. With little maintenance put into the care of this famous billboard, the only hopes for preservation would be by an individual or organization that would realize the important role they played in the lives of so many people growing up in the North Minneapolis neighborhoods.

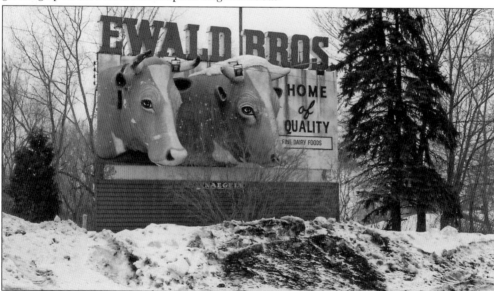

This image captured the attention of the Minnesota State Fair administrators, who made an offer to the dairy to purchase the billboard for $3,500. Knowing the amount of restoration work it would take to bring this sign back to life, the fair administrators did as promised and secured the purchase.

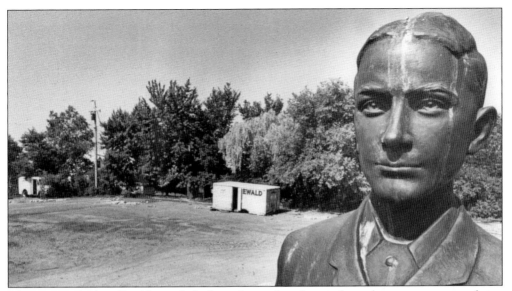

The statue of Chris Ewald stands looking forward and away from the now empty employee parking lot, except for the last Divco and commercial truck. With trees heavily overgrown in the background, the view of the once expansive land the Ewald boys farmed is blocked.

This simple billboard in the familiar gold and white colors replaced a smaller version of the Guernsey cows that once greeted passersby on their way to North Minneapolis. The sign was frequently changed by Naegele Outdoor Advertising and decorated at Christmastime with "Seasons Greetings" and a larger-than-life animated Santa Claus next to it.

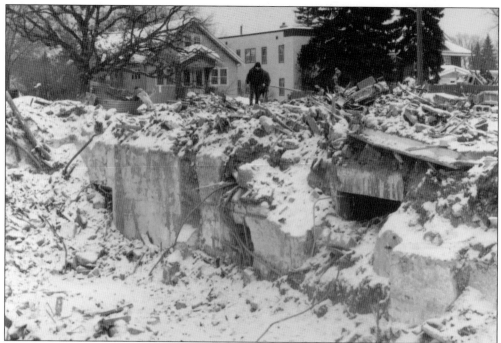

Demolition is in progress, with a young Richard Ewald, great-grandson of Chris and grandson of Ray Ewald, walking through the debris. The lower-level garage is seen here.

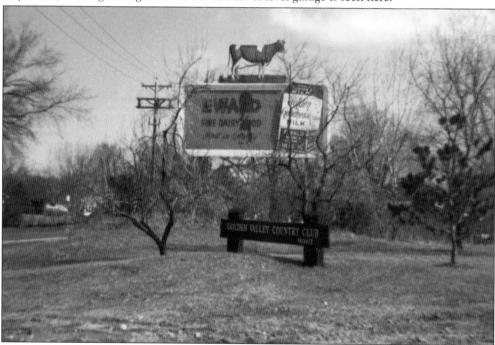

The very last Ewald sign was located on the grounds of the Golden Valley Country Club. Pictured here in 1985, the sign stood for years after the building was demolished. The country club eventually tore it down once Ewald Bros. Dairy's final delivery had been made by Marigold Foods in an Ewald truck.

The shell of a former commercial truck is all that remains of the trucks that were once considered "moving advertising," as stated by Ray Ewald to longtime milkman Einar Hamborg. Hamborg was responsible for the key accounts in Downtown Minneapolis and navigated his large commercial trucks through the alleys of Minneapolis's downtown.

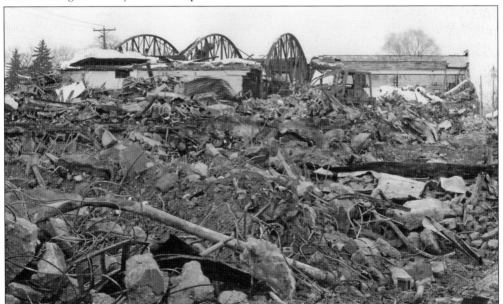

The bow-frame structure of the loading and cooler room area of the dairy still stands in the debris. This type of construction was very popular and known for its durability, especially under the weight load of Minnesota winters. The foreground shows the former offices and headquarters completely reduced; the background shows the partial remains of the two-story garage.

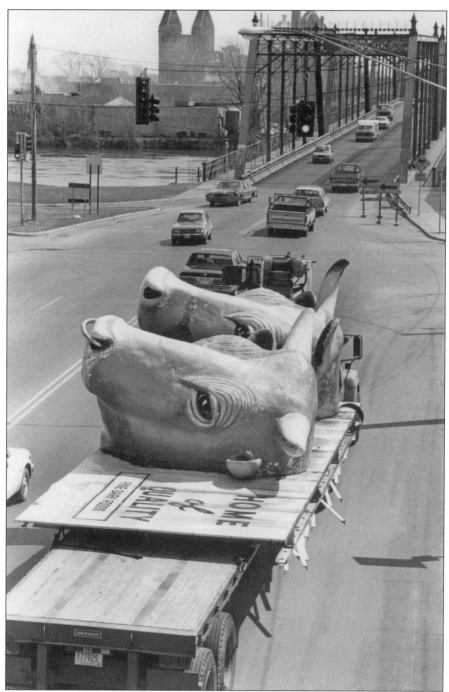

The Ewald Golden Guernsey cows, which for more than 40 years kept watch over the dairy, take a ride to their new home at the Minnesota State Fairgrounds from their former location at 2919 Golden Valley Road. They are shown here on Broadway and West River Road approaching the Broadway bridge after a close fit under the Soo Line Railroad overpass. The pair was purchased by the state fair administrators and initially placed into storage to be refurbished prior to installation at the fairgrounds.

On November 12, 1980, an auction was held for all the equipment that remained inside the dairy after it had been vacated. A mixture of very old equipment along with new, high-tech equipment reflected the new owner's desire and futile attempts to bring in modern equipment to help with the processing. Among the items in this auction are 40,000 metal milk crates that once held half-gallon cartons.

Having been refurbished by the Minnesota State Fair in 1982, the Ewald Guernsey cows have attracted attention from all over the nation. The creator of the billboard, Bob Johnson, passed away in 2016, and many front-page articles in national publications recognized his work.

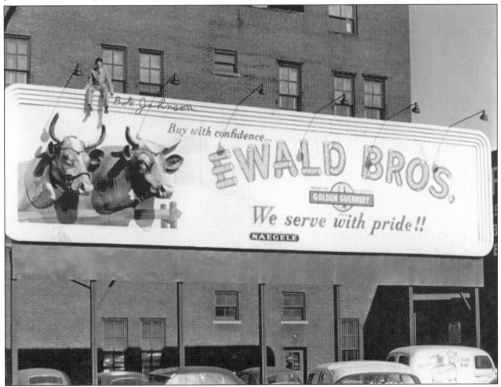

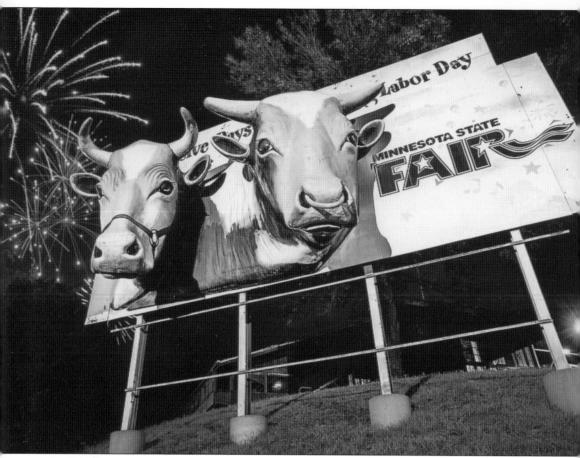

In 1983, having just arrived at their new home at the Minnesota State Fair, the famous Guernsey cows received a fresh coat of paint. Today, these locally-built cows still reside on the fairgrounds and overlook the dairy building on Como Avenue in St. Paul.

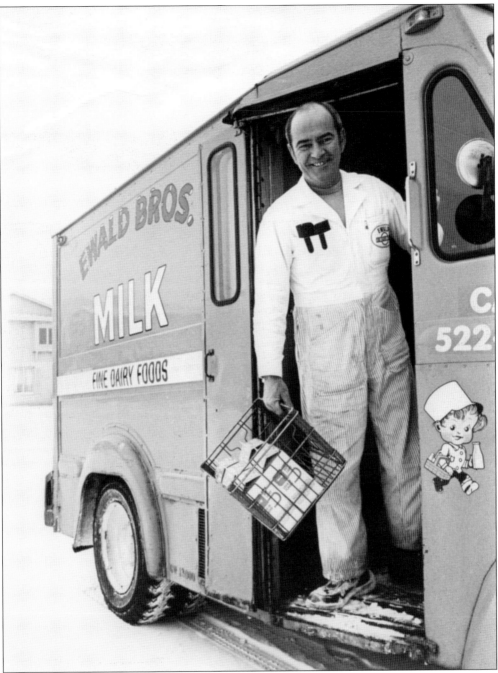

In late 1969, the decision to drop the nationally recognized brand Golden Guernsey was made by the only surviving Ewald brother, Dewey. For almost 40 years, Ewald Bros. Dairy had an exclusive relationship with Golden Guernsey allowing them to be the sole Minneapolis distributor of this well-recognized brand. In addition to severing the Golden Guernsey contract, Dewey also cut ties with Naegele Outdoor Advertising, removing the very billboards that made the company so well recognized. This truck shows the new branding for Ewald Bros. Dairy; it kept the familiar Ewald typeface but changed its motto to "Fine dairy foods."

DISCOVER THOUSANDS OF LOCAL HISTORY BOOKS
FEATURING MILLIONS OF VINTAGE IMAGES

Arcadia Publishing, the leading local history publisher in the United States, is committed to making history accessible and meaningful through publishing books that celebrate and preserve the heritage of America's people and places.

Find more books like this at
www.arcadiapublishing.com

Search for your hometown history, your old stomping grounds, and even your favorite sports team.